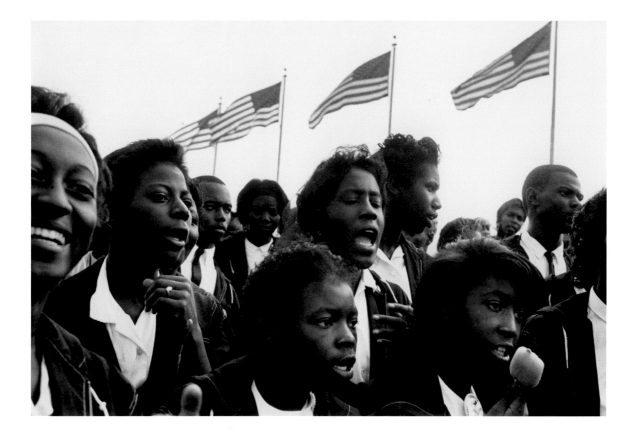

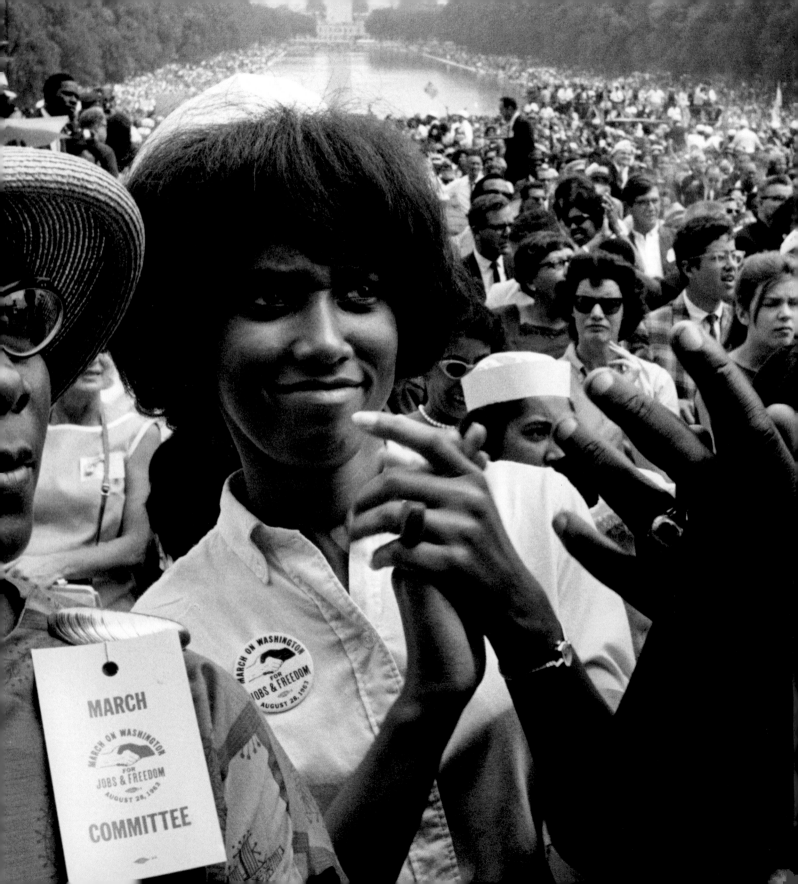

Leonard Freed

This Is the Day
The March on Washington

Foreword by
Julian Bond

Essay by
Michael Eric Dyson

Afterword by
Paul M. Farber

The J. Paul Getty Museum, Los Angeles

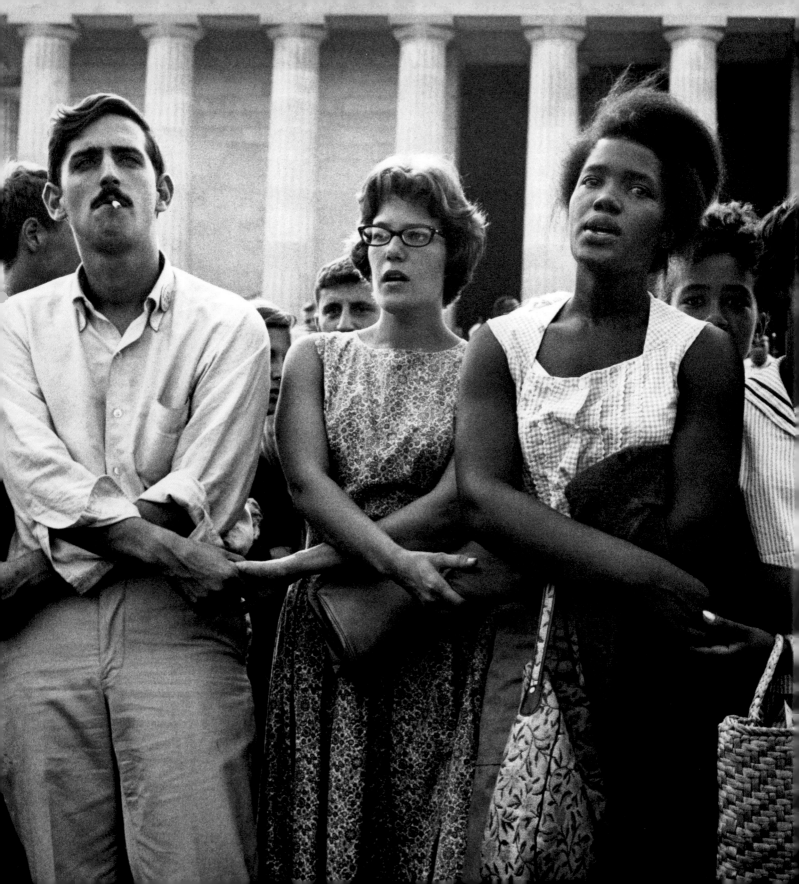

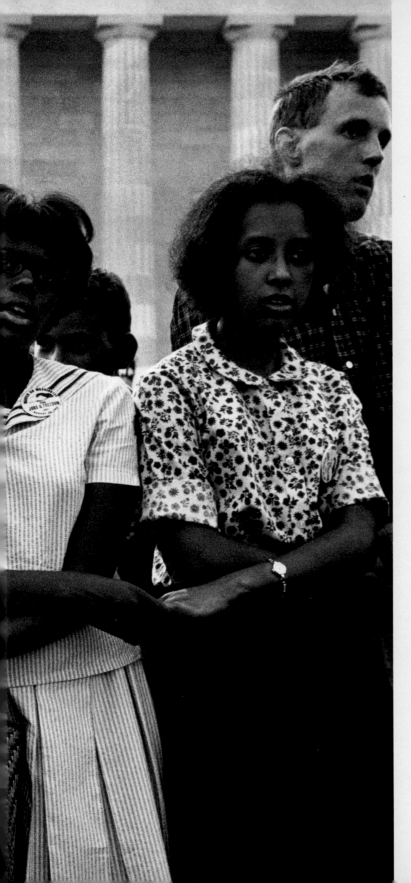

Foreword

Julian Bond

With a quarter of a million others I gathered at the National Mall in Washington, D.C., on August 28, 1963, to attend what became known as the March on Washington for Jobs and Freedom. Sponsored by civil rights organizations and intended to help prod Congress to pass President John F. Kennedy's civil rights bill, the march was the inspiration of the venerable labor leader A. Philip Randolph. Randolph had threatened a similar march in 1941 that was canceled after President Franklin D. Roosevelt issued an executive order ending discrimination in the war industries.

Planners of the 1963 march envisioned one hundred thousand people coming to Washington for two days of protests that would include blocking all legislative business in Washington and presenting Congress and the president with a legislative agenda that would draw attention to "the economic subordination of the American Negro" and the need for creating "more jobs for all Americans."

Randolph approached civil rights leaders Roy Wilkins and Whitney Young. Both were less than enthusiastic about the idea, and Martin Luther King Jr. expressed little interest, as he was in the middle of the Birmingham campaign.

By June 1963, however, King was ready to discuss the idea. Kennedy's leadership during the Birmingham crisis had been "inadequate," he said. The civil rights movement should sponsor an interracial march on Washington that could include sit-ins on Capitol Hill. But Kennedy's dramatic civil rights speech on June 11 overwhelmed King, and he decided that the focus of the march should be on Congress, not the president.

On July 2, 1963, the heads of the sponsoring organizations gathered in New York to discuss the March on Washington—leaders of the National Association for the Advancement of Colored People (NAACP), the Brotherhood of Sleeping Car Porters, the Congress on Racial Equality (CORE), the Student Nonviolent Coordinating Committee (SNCC), and the Urban League. After arguing over whether activist Bayard Rustin's homosexuality and past membership in the Communist Party made him a potential source of controversy, they agreed that Randolph would be the march's official leader and Rustin would be its organizer.

The next day the march was formally announced. It would focus on jobs and black unemployment, not just on new civil rights laws. The leadership announced that no civil disobedience would occur; the march had already begun to lose the militant edge Rustin had first envisioned.

In August 1963 the six members of the march's black leadership team were joined by four whites: Walter Reuther of the United Auto Workers, Protestant clergyman Eugene Carson Blake, Rabbi Joachim Prinz, and Catholic layman Matthew Ahmann. Labor unions, church groups, and civil rights organizations across the country mobilized their members and supporters for the march.

The march schedule called for all speakers to have advance copies of their remarks ready for press distribution the day before the event. King didn't, but SNCC Chairman John Lewis did, and what he was prepared to say raised objections from Attorney General Robert F. Kennedy. The original text stated that SNCC could not support the administration's civil rights bill. "It is too little and too late," Lewis planned to say. The original draft of his speech goes on:

> We will march through the South, through the heart of Dixie, the way Sherman did. We shall pursue our own "scorched earth" policy and burn Jim Crow to the ground—non-violently. We shall fragment the South into a thousand pieces and put them back together in the image of democracy.

He also attacked the administration's appointing racist judges: "Which side," he asked, "is the federal government on?"

Attorney General Kennedy spoke to Patrick Cardinal O'Boyle, the archbishop of Washington, D.C., who was to deliver the invocation. Cardinal O'Boyle, acting for the Kennedy administration, raised objections to Lewis's speech, as had other leaders of the march. At a meeting late on the night before the march, Lewis refused to change a word. The controversy continued onto the Lincoln Memorial the next day. Cardinal O'Boyle threatened to boycott the march, saying he would not appear unless he had Lewis's changed speech in his hands ten minutes before the program began. After hasty consultations in a room behind Lincoln's statue, Lewis agreed to the changes.

Author Nick Bryant, in his 2006 book *The Bystander: John F. Kennedy and the Struggle for Black Equality*, describes the wide range of behind-the-scenes governmental preparations, of which the marchers were completely unaware. He reports that on the day of the march,

The District of Columbia was placed under virtual martial law, with the president ordering the biggest peacetime military buildup in American history. . . .

Almost 150 [FBI] agents from the Washington field office were assigned to mingle in the crowd, working in tandem with the Secret Service. Other FBI agents were stationed at rooftop observation points on the Lincoln Memorial, Union Station, and the Commerce Department. . . . A policeman or National Guardsman would be stationed on every corner in [the] downtown business district to guard against looting.

In addition, Washington police chief Robert V. Murray

mobilized 1,900 of his 2,930 officers, and ordered them to work eighteen-hour shifts rather than the usual eight. [He] called up 200 scout cars, eighty-six motorcycles, twenty-four jeeps, several police helicopters, and twenty-three cranes to move broken-down buses. . . . In the city's courtrooms, a team of local judges was placed on round-the-clock standby, while 350 inmates from the district jailhouse were evacuated to create space for any disruptive protesters.

Missing from this human and mechanical arsenal were Washington's sixty-nine police dogs, which remained in their kennels on the orders of Robert Kennedy, to avoid a repetition of the ugly images of Birmingham. In an effort to improve the image of the Washington police, the city also canceled its long-standing segregationist practice of allowing white officers to bar black policemen from riding in their squad cars. Yet the military buildup continued:

By midmorning on August 28, five military bases on the outskirts of the capital were bursting with activity—and a heavily armed, 4,000-strong task force, with the code name INSIDE, prepared for deployment. At Fort Myer, Fort Belvoir, Fort Meade, Quantico Marine Base, and the Anacostia Naval Station, thirty helicopters had been flown in especially to provide airlift capability. At Fort Bragg, North Carolina, 15,000 Special Forces troops, dubbed STRICOM, were placed on standby, ready to be airlifted at the first sign of trouble.

On the ground, site preparations included protection against a possible commandeering of the public-address system:

> [Security planners] decided that an administration official should sit to the right of the Lincoln Memorial with an automatic cut-off switch, along with a record turntable. If protestors overran the speaker's platform, the sound feed would be cut and replaced by Mahalia Jackson singing "He's Got the Whole World in His Hands."

But there was no need for these ominous and potentially catastrophic crisis plans. The march proceeded without any disruption.

Leonard Freed's photographs of the March on Washington depict both the march and the marchers. Many are dressed as if for a Sunday gathering, a special event demanding respect from all in attendance. For the participants, this was both a serious and a happy occasion, a chance to exercise their rights and to petition their government for a redress of ancient grievances. The marchers are at once sober, somber, and gleeful—proud to be present as they sense that history is being made. For those who were there, and for those who watched from afar, "This was the day." ∎

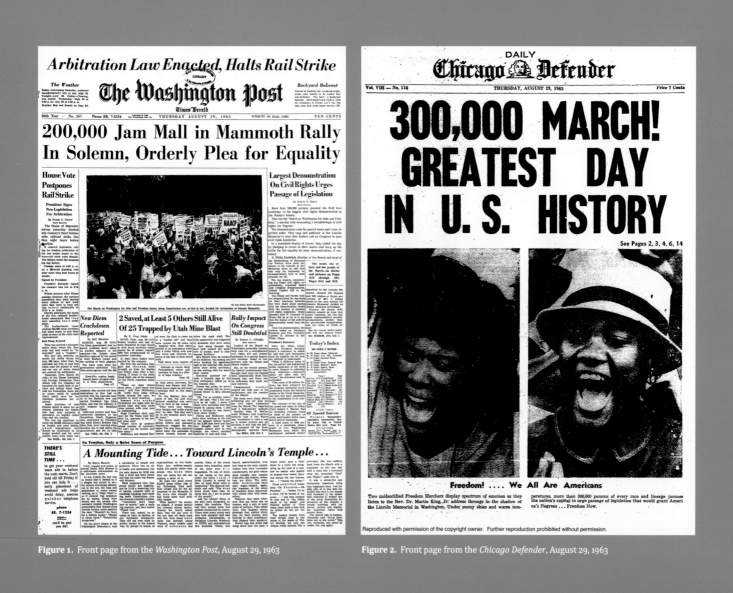

Figure 1. Front page from the *Washington Post*, August 29, 1963

Figure 2. Front page from the *Chicago Defender*, August 29, 1963

August March

Michael Eric Dyson

There have been many marches since, and several before, but no other march to the nation's capital captured our collective imagination like the March on Washington of August 28, 1963. It was undoubtedly one of the greatest gatherings of American citizens since the republic's birth. The March on Washington branded the protest march like Xerox branded copying machines, like Apple branded computers. The circumstances of the march make it remarkable that it came off at all. The march was composed of eclectic groups with varying purposes: the moderate National Urban League, for instance, sought to rescue the Negro from urban peril, while the insurgent Student Nonviolent Coordinating Committee wanted to protect the Negro from white terror. The march also exploited colorful if tenuous alliances between Jews and blacks, between labor and civil rights groups, and between religious believers and secular activists. The drama that engulfed the planning of the march put soap operas to shame: the leadership class nursed petty jealousies and ugly rivalries while jostling for position before television cameras. The momentous pilgrimage also showcased an inspired pairing: Martin Luther King Jr., the celebrated leader of black America who hadn't yet delivered an entire speech that the nation had listened to, and Bayard Rustin, whose organizational genius drew masses to D.C. despite the open secret of his homosexuality.

The internal problems that plagued the march were mild compared to the intimidation of ordinary black people. In the Deep South most whites saw joining the NAACP as racial surliness, a defiant and uppity gesture worthy of brisk unemployment and a kick in the pants, or worse yet, a literal shot in the dark. If local organizing provoked white anger, a national protest aimed at winning jobs and freedom for black folk was utterly infuriating. The routine brutality that stalked black life also leapt over white borders: many whites were attacked or murdered for their solidarity with black struggle.

Powerful whites who sympathized with black life often did so in an abstract fashion. They passed the liberal smell test, but when scratched they often bled in faint spots of moderation. They were typically more spooked by strong black protest against injustice than by the white violence that caused blacks to resist. King faced this challenge in 1963 from eight white clergymen who implored him to take the gradual approach to social revolution in Alabama. King's response was his famous "Letter from Birmingham Jail," trumpeting black folks' "legitimate and unavoidable impatience." The civil rights leader reprinted his searing missive in a book whose title said it all: *Why We Can't Wait.*

King and other leaders also met stiff resistance from President John F. Kennedy, who wasn't nearly as progressive as the figure he played on television. Kennedy lamented in a presidential meeting three months before the march that "King is so hot these days that it's like Marx coming to the White House." Although King didn't pen it, the title of Nick Bryant's book *The Bystander* neatly summarizes Kennedy's equivocating stance on civil rights. Kennedy didn't hide his opposition to the march from King and his colleagues. "We want success in the Congress, not a big show on the Capitol," Kennedy argued in a meeting with civil rights leaders. It was only after the triumph of the march that the young commander in chief greeted the even younger civil rights hero in the White House on the very afternoon of King's glorious achievement with the magical refrain from his instantly immortal oration: "I have a dream," the president said as he beamed a smile at King.

The march's resounding success made all the paranoia about any possible trouble seem typically overplayed: Washington police and the U.S. military were poised as if for an insurrection. Such fears have hardly died even in our day. The tragic death in February 2012 of Florida teen Trayvon Martin is sad proof of racism's bitter persistence. Trayvon was a 17-year-old black youth murdered by George Zimmerman, a 28-year-old neighborhood watch volunteer who got drunk on the poisonous brew of black suspicion. Zimmerman killed the teen because Trayvon looked like he was "up to no good" as he walked back to the home of his father's fiancée in a gated community, armed only with Skittles and iced tea. Zimmerman claimed self-defense, but Trayvon's only crime seems to be that he was young and black. Outrage at Trayvon's senseless death sparked protests across the nation.

Trayvon's death echoes the epic loss of another black teen, Emmett Till, whose 14-year-old body was mutilated, murdered, and tossed into Mississippi's Tallahatchie River in 1955 with a 70-pound cotton-gin fan tied around his neck, held in place by barbed wire. Till's death unleashed tidal waves of mourning and memory that swept thousands of activists into the titanic struggle for justice. Rustin and his colleagues surely weren't oblivious to the poignant symbolism of holding the march on the eighth anniversary of Till's epochal sacrifice.

While Till's premature martyrdom haunted the movement, A. Philip Randolph furnished the march's enduring political rationale. Randolph's long and colorful odyssey as a civil rights and labor leader culminated in organizing and heading the Brotherhood of Sleeping Car Porters, the nation's first predominantly black labor union. Along with Rustin, Randolph organized the March on Washington Movement (MOWM), which lasted from the mid-thirties to the late forties. The purpose of the MOWM was to pressure the government to desegregate the armed forces and to provide fair employment opportunities for black folk. In 1941 Randolph, Rustin, and pacifist A. J. Muste called for a march on Washington to highlight black grievances and demand concerted government action. After national organizing efforts led to the prediction that more than one hundred thousand marchers might descend on the nation's capital in protest, President

Franklin D. Roosevelt issued Executive Order 8802. Roosevelt's action established the first Fair Employment Practices Committee (FEPC), leading Randolph, Rustin, and Muste to call off the march less than a week before it was scheduled to take place, but only after they made sure that government employment for blacks was also covered in the presidential order. Although MOWM was founded to call for a march on Washington, it lasted until the late 1940s as a force to urge the federal government into just action on behalf of beleaguered blacks.

More than twenty years after Randolph's initial organizing for a march on Washington, and in the centennial year of the Emancipation Proclamation, the time seemed right for a renewed effort to dramatize the Negro's demand for jobs and freedom by flocking en masse to the nation's capital. By 1963 Randolph's visionary activism, organizational talent, stirring oratory, and regal bearing made him, at seventy-four years of age, the great old man of black leadership and the titular head of the March on Washington. Rustin was the perfect organizer. He was a distinguished social activist and theoretician of nonviolence who had worked alongside Randolph in many causes. Rustin later served as an adviser to Martin Luther King Jr., whose potential he spotted early on, before heading south to help the young minister understand and implement Gandhian tactics of nonviolence in the 1956 Montgomery Bus Boycott. The following year Rustin helped King to organize the Southern Christian Leadership Conference.

Rustin had the unenviable task of corralling competing forces to make the march a success. The black male leaders of major civil rights groups formed the march's organizational core. Dubbed the "Big Six," these men at times had conflicting ideas about the best route to racial redemption. For instance, the gifted Roy Wilkins favored action in the courts rather than activism in the streets, and had a special distaste for King's style and approach to social justice. Whitney Young was a talented organizer who awakened the group from its social slumber and made it relevant to the black freedom struggle. He was also chummy with white corporate titans, a close adviser to Kennedy, and later to Presidents Johnson and Nixon. Young's proximity to the White House was a sore spot later on when King criticized the Vietnam War and Johnson played the two leaders against each other.

There were many hurt egos about who would and would not speak. The leaders omitted noted writer James Baldwin, and Rustin only belatedly invited the Birmingham movement hero Rev. Fred Shuttlesworth to the podium when the other speakers were in tense negotiations over the controversial elements of John Lewis's speech. The absence of women was a glaring omission. The wives of the male leaders weren't allowed to march with their husbands, and no woman spoke during the proceedings except expatriate performer Josephine Baker. Two black female stars managed to take the stage. Opera great Marian Anderson performed "He's Got the Whole World in His Hands," and gospel legend Mahalia Jackson let loose with "I Been 'Buked and I Been Scorned," an ironic if unintended commentary on the treatment of women as well. A token "Tribute to Women" called on notable women activists to take a bow, including Rosa Parks, Daisy

Bates, Diane Nash Bevel, and Gloria Richardson. Even the great Dorothy Height, a presidential adviser and head of the National Council of Negro Women, who surely qualified as one of the "big" leaders, wasn't invited to speak. Women were barely seen and largely unheard that day.

The rhetorical and symbolic centerpiece of the march remains Martin Luther King Jr. His remarkable oration that day still resonates at the heights of American rhetoric, though behind-the-scenes drama surrounded his speech as well. As black leaders jockeyed to appear early in the program to assure television coverage, and to avoid speaking after King, they had little idea of how quickly the march's magnitude would capture the nation's attention. By the time King stood to deliver his speech, after being memorably introduced by Randolph as the "moral leader of our nation," ABC and NBC joined CBS, the only station scheduled to cover the march. Together they provided full network coverage of an event that grew well beyond its predicted impact on the approximately two hundred fifty thousand protesters gathered (see figs. 1, 2). The march registered around the globe as a seismic shift in the presentation and portrayal of black intelligence in the service of social justice and the public good.

King started slowly and deliberately, his rich baritone resounding throughout the crowd as he self-consciously linked himself to Lincoln's legacy by alluding to Lincoln's language in the Gettysburg Address, counting years clumped together in arcane bushels of scores. Lincoln began his 1863 address "Four score and seven years ago," referring to the American Revolution in 1776, while King began his 1963 speech "Five score years ago," referring to Lincoln's signing of the Emancipation Proclamation. King gained immediate purchase on the dynamics of American democracy and the dilemmas of American race in one fell rhetorical swoop.

King steadily built his oration—or in the language of black preachers he "argued his case"—on a series of metaphors that clarified his moral rendering of history from the angle of democracy's delayed beneficiaries. The nation had bounced a check to black people that King and his colleagues had come to collect for us all. Millions of black folk had been unjustly marooned on an island of poverty in the midst of an ocean of prosperity—material prosperity, he was careful to say, suggesting that other forms of well-doing were meager consolation at this historical juncture, anticipating President Lyndon B. Johnson's War on Poverty less than a year later.

King's measured cadence and euphonious delivery masked the radical character of his speech. King said that there would be "neither rest nor tranquility in America" until Negroes gained full citizenship, and he spoke of the "whirlwinds of revolt" that would continue to "shake the foundations of our nation" until justice is done. King railed against police brutality, the stunted social mobility of poor blacks in urban ghettoes, and the chronic assault on black selfhood and personal dignity.

Women may have been barred from the speaker's stage, but at least one of their voices ranged far beyond where their bodies had been exiled. Mahalia Jackson noted that King's usual rhetorical freedom had been

stifled under the weight of history and the demands of a written speech. She evoked a bit of holy bois-terousness and encouraged her friend to depart from paper and soar to oratorical heights in the careful improvisation that marks black speech at its best: "Tell 'em about the dream, Martin," she bellowed from the background, rescuing King and changing history on the strength of a verbal interjection, a sweet call and response not uncommon in the black church.

And respond to her call King did. Even if his ears didn't hear her, his soul did. King cast aside his prepared speech and offered the world a glimpse of black rhetorical genius. King conjured bits and pieces of other orations to weave the dream metaphor into the tapestry of the nation's self-image, and in the process he grafted black folk to the heart of American democracy. He dreamed about his children being judged on character, not color. He dreamed of the day when the offspring of slaves and the offspring of their former owners might enjoy each other's humanity. He dreamed that Mississippi might be made over in the image of justice and that Alabama might redeem its destiny because its youngest citizens joined hands. He dreamed that true biblical inspiration might spill over into the corridors of hope and faith and baptize the freedom songs of suffering servants. He dreamed that his dream might be recognized as America's dream, and that freedom might ring from the great peaks and resound in the downcast valleys of the American soul. And he dreamed in such a way that the blues and the spirituals were reconciled in an exhilarating moment of moral synergy that mirrored the unity he wished on the American people.

If King's thrilling and masterly oration rose from the belly of black suffering, bounded over hurdles of national power, and captured American moral aspiration, then the folk gathered on the National Mall put body and face to King's resilient dream. Leonard Freed's moving photography offers still images of an America at once frozen in time and marching restlessly to its multicultural and multiracial future through the lens of a visionary artist. Freed's photographs are more than snapshots; they are portraits of social possibility set against the backdrop of a nation grappling with the exclusionary obsessions of one race, one gender, one sexuality, one age, one religion, and one region. Freed's photographs of the day offer instead the expansive possibilities of many races, many genders, many sexualities, many ages, many religions, and many regions gathered on the Mall to call for change.

But he does something more, without either agenda or political motivation, making his visual testimony even more powerful: He photographs the rainbow of blackness that floats above prescribed definitions of beauty and intelligence. Dark-skinned blacks who were usually only photographed in buffoonish extrava-gance get from Freed a forgiving realism that rescues the blackest blacks from the wasteland of stereotype and restores them to majestic ordinariness. They are marching as much for the freedom to breathe the air of their luminous darkness—with their chocolate skin and their neatly cut kinky hair or their freshly pressed coifs—as for the right to live free of the lynch mob or the poll tax.

Freed also captures white faces and bodies as a drop in a black ocean, not the other way around, reinforc-ing the fact that the global majority even then were people of color. But the subtle politics of capturing

such portraits suggest justice, or the search for it, as the basis for peaceful coexistence. What Freed's photos do, too, is document white investment without the pretense of superiority or the burden of nobility. The aims of King's speech find forceful symmetry in the aim of Freed's camera.

The moral beauty of Freed's photographs bathes the aesthetic that guides his flow of images. The folk here are neat, dignified, well-dressed—in a word, *sharp*, with all the surplus meaning the word summons, since black dress can never be divorced from political consequence. The black desire to dress elegantly, or failing that, to dress noticeably, reflecting complicated dimensions of black life and aspiration, marked our existence then as surely as it does now. Well-dressed black folk decked out in their Sunday go-to-church clothes, or their Saturday go-to-party rags, often offended whites who resented even a thread of evidence that black folk were prospering beyond their desert, or beyond comparative white means. Freed captures the simple dignity and the protocols of cool—the ethics of decorum—that characterize large swaths of black life. And when his camera swings wide to include a vision of America too rarely noticed in the mainstream press at the time, and in some cases even now, he records almost mundanely, and hence rather heroically, the everydayness of the encounters between white and black. He allows the images to steep in the crucible of American race. One can almost catch the subliminal suggestion: This is what it should always be like. The photograph of blacks and whites linking arms in the culminating rendition of "We Shall Overcome" is sweet "I sing" on the cake of unity.

The single Freed photograph from the march that includes King's presence, if not his discernible image, is instructive in its courageous stinginess and in its polar distance from the iconic figure (see page 63). A year later Freed captured King in one of the most famous shots of the leader as a throng of admirers lay hands on him in a passing motorcade celebrating King's receipt of the Nobel Peace Prize (fig. 3). But on the day of the march, Freed positions himself far off and below the steps of the Lincoln Memorial as King delivers his speech. Freed thus achieves visually what scholars have labored to do intellectually: to show that no matter how dominant a figure King was, he wasn't the only, and often not even the primary, vehicle for the civil rights movement. Freed's photo also suggests that no matter how much we think we know King, how close we thought we were to him, he was in truth a far more complicated man who struggled with personal demons and unpopular political ideas as he tapped the vein of social revolution.

Like Freed's photographs, the movement didn't stop in 1963 on the National Mall. The civil rights movement's struggles for nonviolent social change continued to unfold in political corridors and popular culture years after its most ballyhooed achievements. The legacy of the March on Washington is still being written, still being contested, still being fought for in the soul of the nation. Conservatives who once ridiculed the movement's goals and gains now sample its rhetoric out of context to perversely oppose the ongoing struggle for justice by contemporary social activists. And folk of every political stripe and ideology who march to Washington, from Minister Louis Farrakhan to conservative media figure Glenn Beck, have to pay homage to the iconic expression of social protest on August 28, 1963. When the National Park

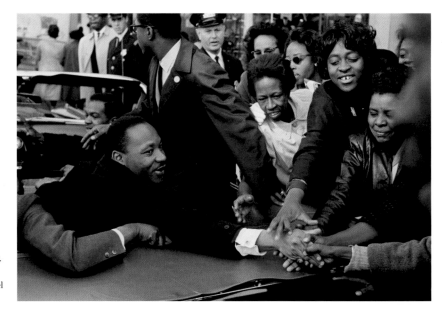

Figure 3
Leonard Freed (American, 1929–2006), *Martin Luther King Jr., Baltimore,* 1964. Gelatin silver print. King being honored in Baltimore motorcade after receiving the Nobel Peace Prize

Service dedicated an inscription in stone to the spot where King delivered his "I Have a Dream" speech, the march's imprint went from symbolic to literal.

Twenty years after the March on Washington, a commemorative gathering sought to recapture the old spirit of struggle and to infuse renewed energy into a flagging movement that was under assault. Freed's photos of the 1983 march show King looming even larger in death than in life. The pensive pose of Jesse Jackson, King's former aide and his successor as the preeminent leader of black folk, also contrasts the styles and times of leadership and of movement building: a more casual atmosphere is glimpsed in Jackson's leisure suit and in the dress of the thousands gathered on the Mall. To be sure, there were still well-dressed men and women; in particular, as photographed by Freed, the immaculately attired men of the Fruit of Islam, the security arm of the Nation of Islam. But there were far more T-shirts and blue jeans as well, suggesting the changed trends and styles in American dress. It also hinted at the relaxing of a black urge to always be properly clothed to avert misfortune—misfortunes that seem to happen more frequently when black folk are deemed to be underdressed or improperly dressed, when police or vigilantes see them as thugs or hoods in fashions that, by the way, pass for casual dress in white America.

Freed's camera captures the signs of the times at the 1983 march: the presence of placards calling for President Reagan to cut the military budget, sweatshirts urging Jackson to run for the presidency, which he would announce almost three months later, and ubiquitous images of King. Most blacks believed that Ronald Reagan was hostile to black interests, except when he signed the King Holiday legislation into law in November 1983, although he had earlier revived baseless and hoary rumors of King's Communist

dealings. The 1983 March on Washington reminded the nation of King's vital legacy and reinforced Jackson's standing as the most visible black leader in America. His presidential runs in 1984 and 1988 would shortly establish Jackson's standing as a creative public moralist while transforming American politics and paving the way for Barack Obama to become the nation's first black president twenty years after Jackson's last campaign.

King's legacy looms large in Obama's life and presidency. In 2010 I interviewed President Obama in the White House. As my interview with him in the Oval Office came to an end, he led me to the bust of Martin Luther King Jr. by Harlem Renaissance sculptor Charles Alston that he had installed near a bust of Abraham Lincoln. Obama's gaunt visage creased in delight as we gazed in silent awe on the face of a man the two of us baby boomers have acknowledged as a great inspiration. In 2011 Obama participated in a far more public recognition of the martyr's meaning when he spoke at the dedication of the Martin Luther King Jr. Memorial on the National Mall. King became the first individual African American to occupy the sacred civic space dominated by beloved presidents like George Washington and Franklin Delano Roosevelt. King's image on the Mall is a sturdy reminder that his story, and the story of the people for whom he died, helped to rescue American democracy and make justice a living creed. King's memorial is even more impressive because his statue rises 30 feet high on a direct line between the likenesses of Jefferson and Lincoln; dwarfing those memorials by 11 feet, it is one of the tallest on the Mall. Even in death, King is still breaking barriers.

It was both fitting and ironic that Obama presided over the cementing of King's status as an icon in the national political memory. Obama's historic presidency is unthinkable without King's assassination and the black masses' bloodstained resistance to racial terror. Obama embraced King's rhetoric of justice during his presidential campaign while eschewing his role as prophet. Presidents uphold the country; prophets often hold up an unflattering mirror to the nation. King may now be widely regarded as a saint of American equality, but he often had to criticize his nation's politics and social habits to inspire and, at times, to force reform. As its loving but unyielding prophet, he helped make America better by making it bend to its ideals when it got off course. Had he lived, King certainly would have hailed Obama's historic feat even as he took issue with some of the president's policies toward black and poor people. It would have been principled criticism rooted in an obsession with improving the lives of the vulnerable.

As King rises on the Mall, and even higher in our national consciousness, he is forever linked to the 1963 March on Washington that made him a household name and a living icon for resistance to racial injustice. King gave his life to transform American society, and, as his martyr's blood sank deep into the soil of national history, new life and political possibilities sprang up from his valiant sacrifice. The 1963 March on Washington offered the nation its first extended hearing of a man whose words would change how we understand race in America. Leonard Freed's images document the poignant impact the march had on those Americans who were fortunate enough to hear the beginning of that change in person. ■

I

The March on Washington for Jobs and Freedom

August 28, 1963

This Will Be the Day

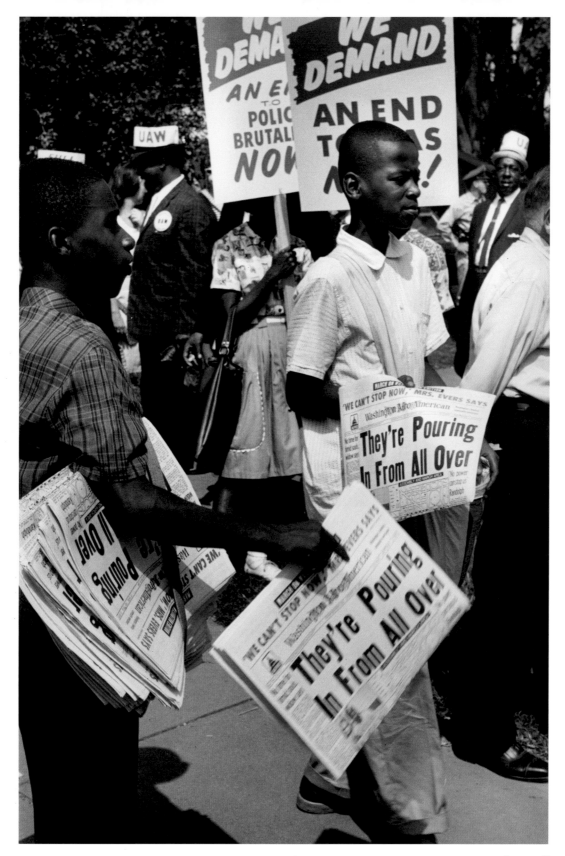

11

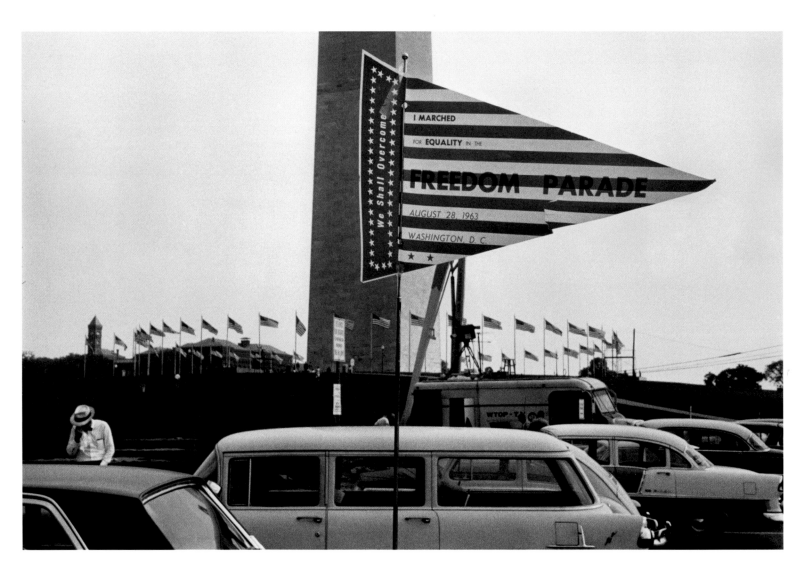

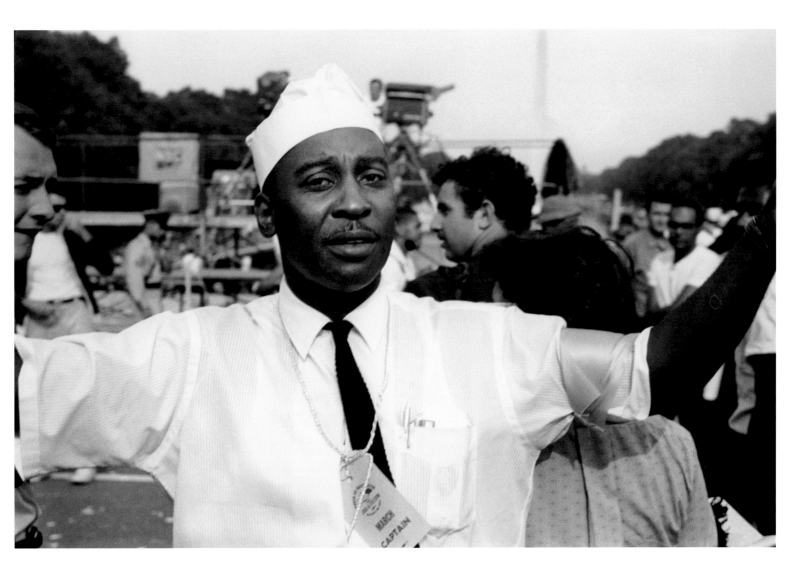

13

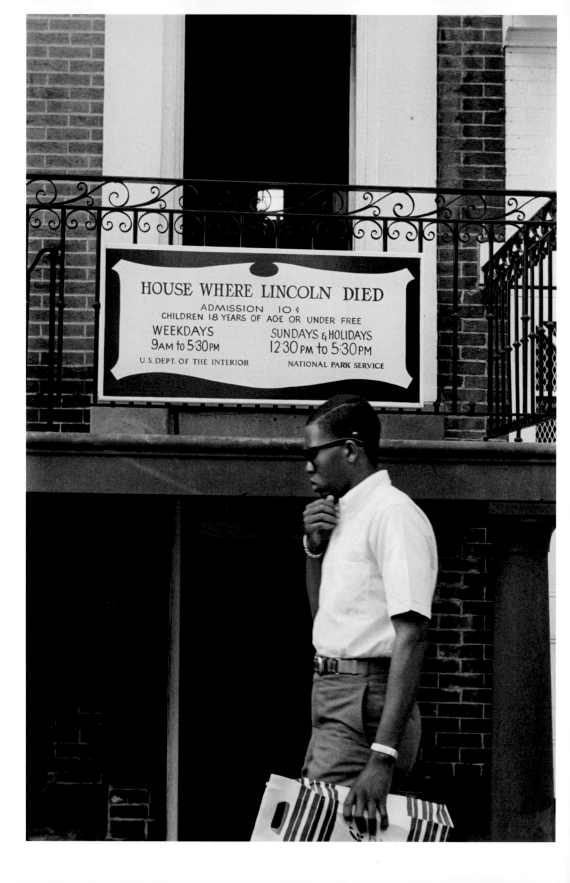

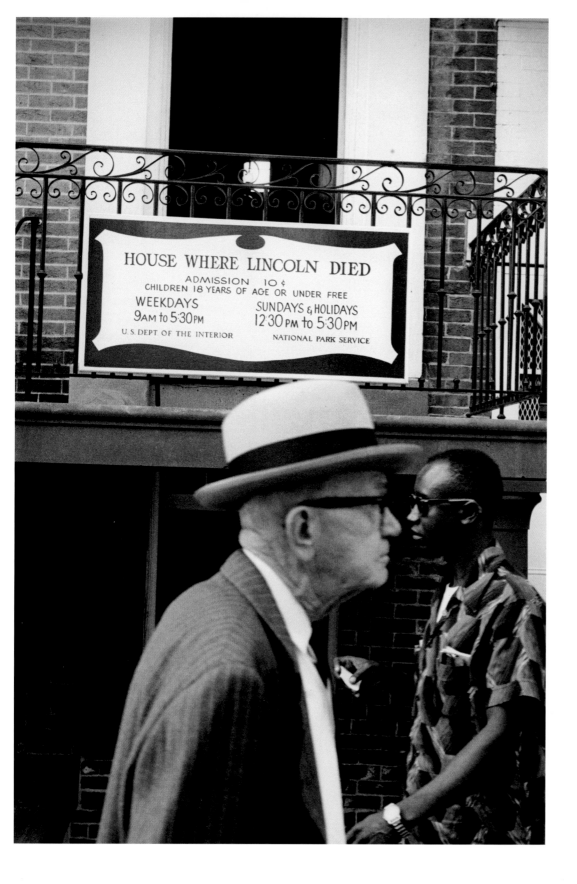

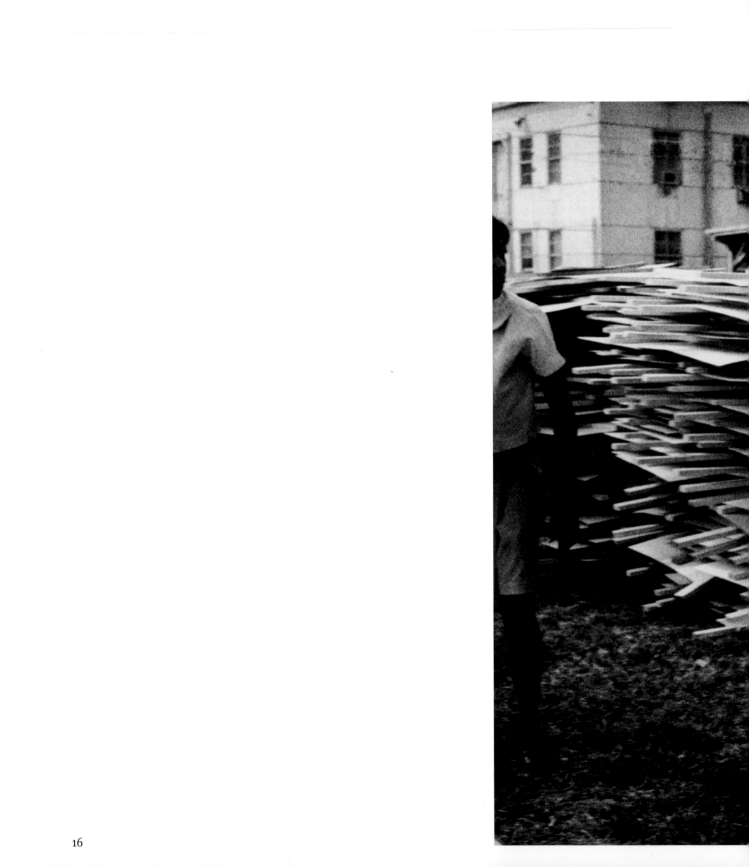

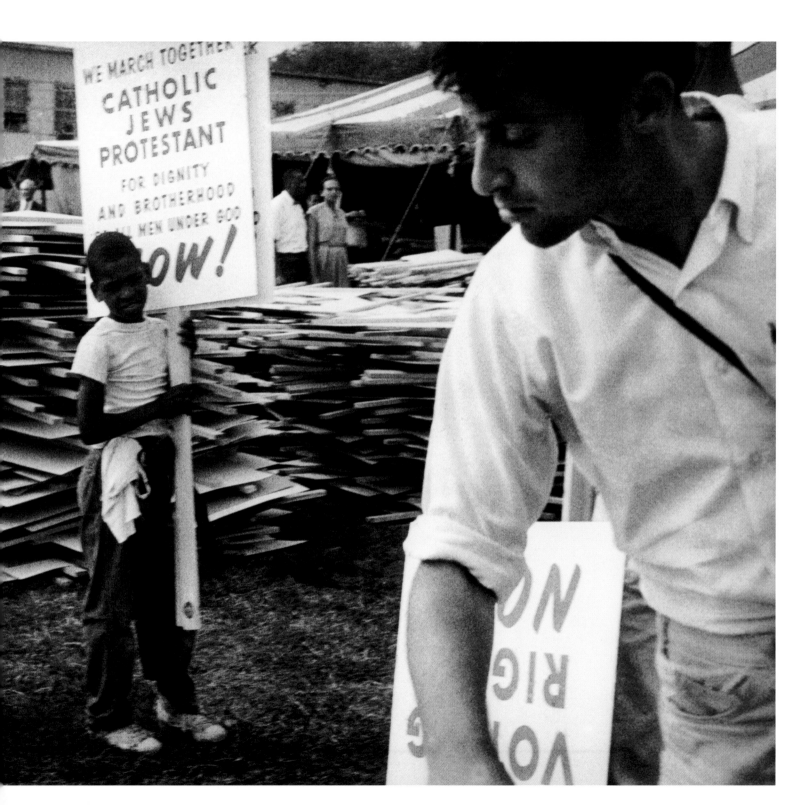

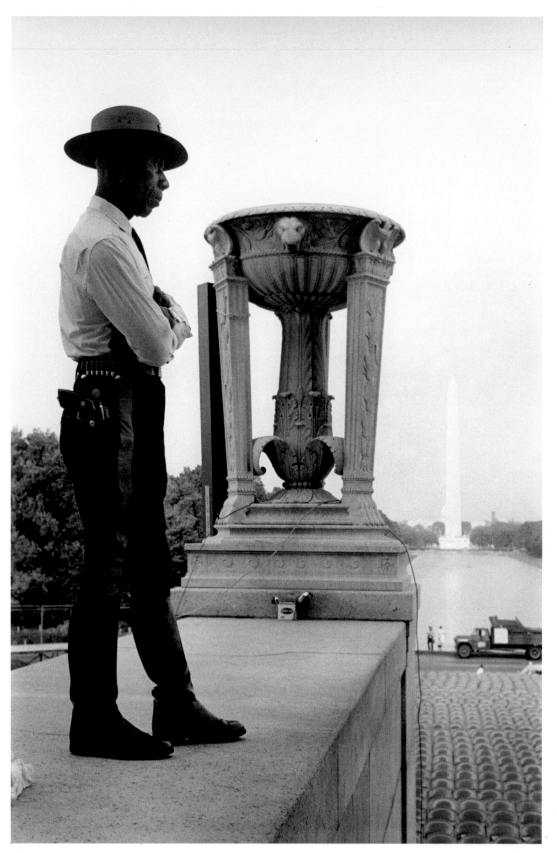

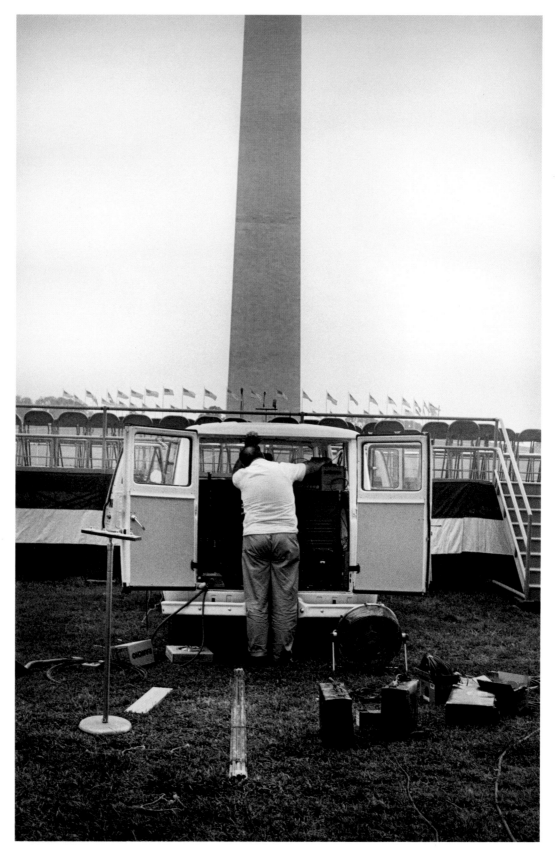

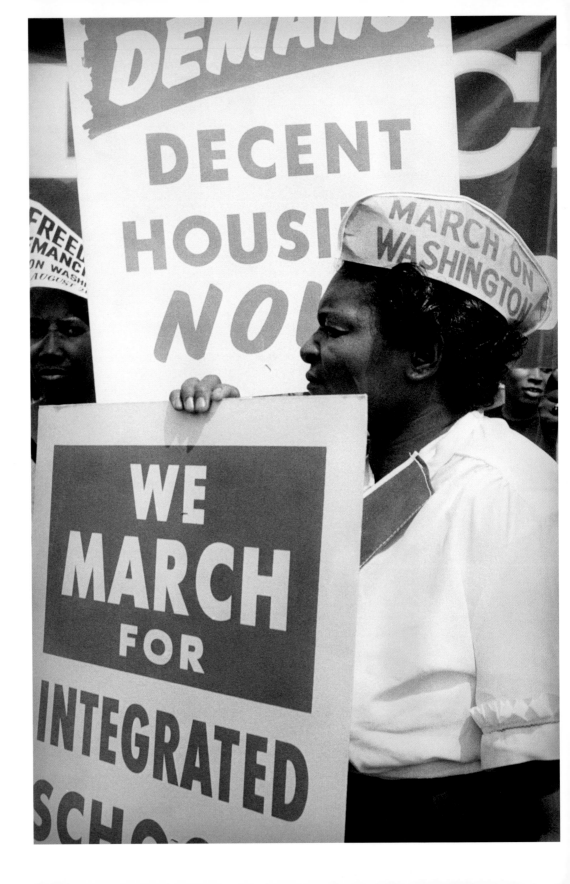

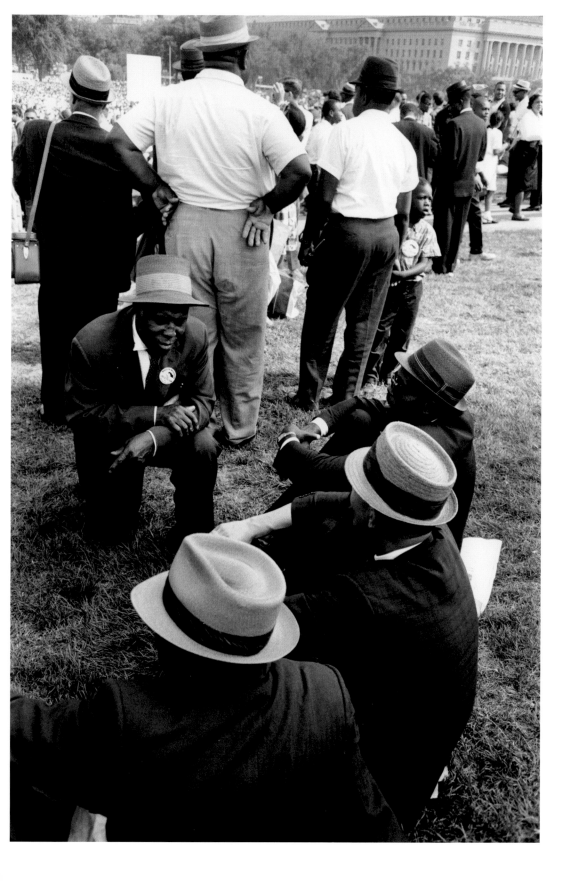

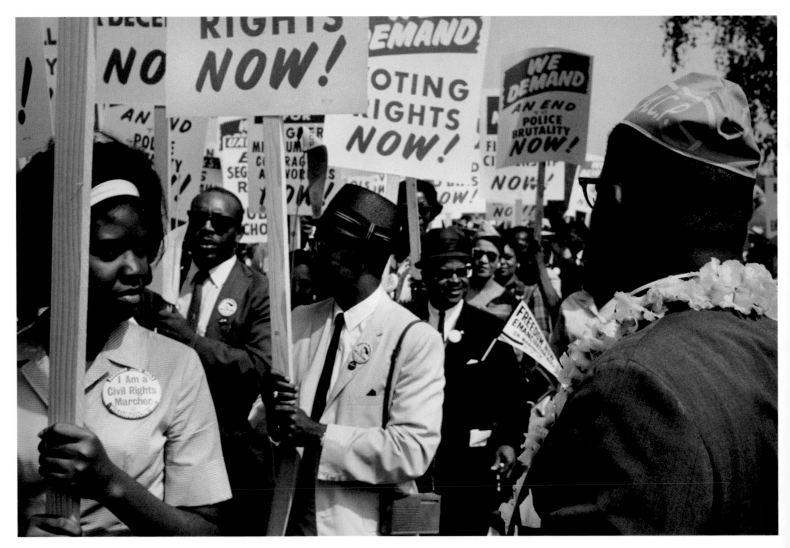

This Is the Day

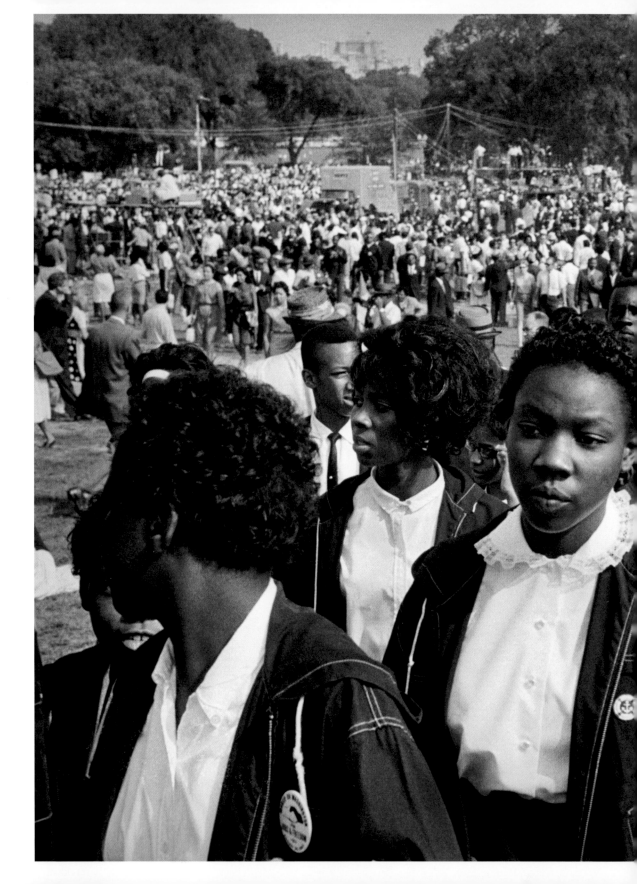

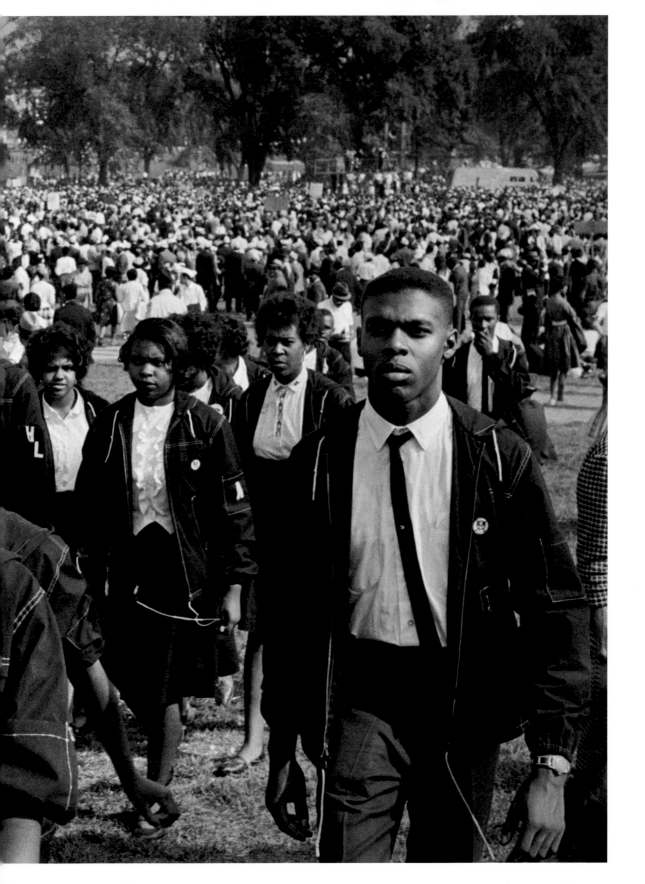

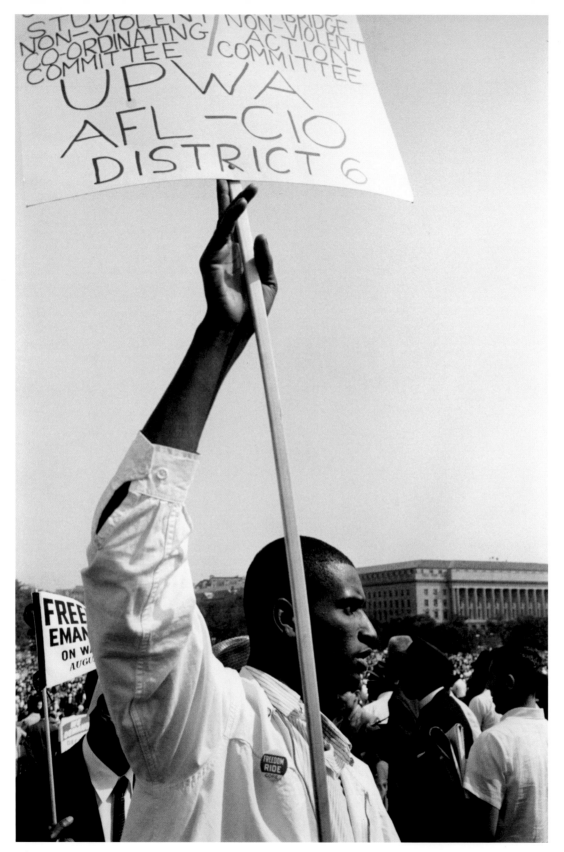

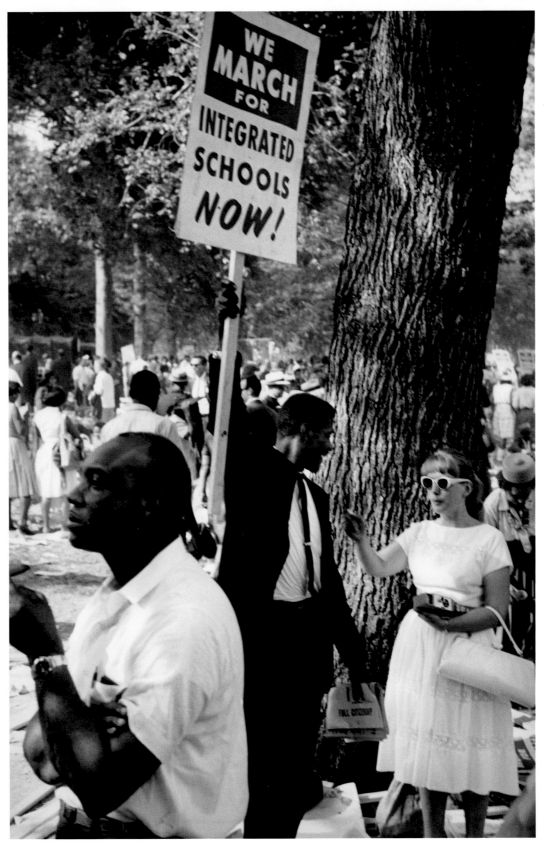

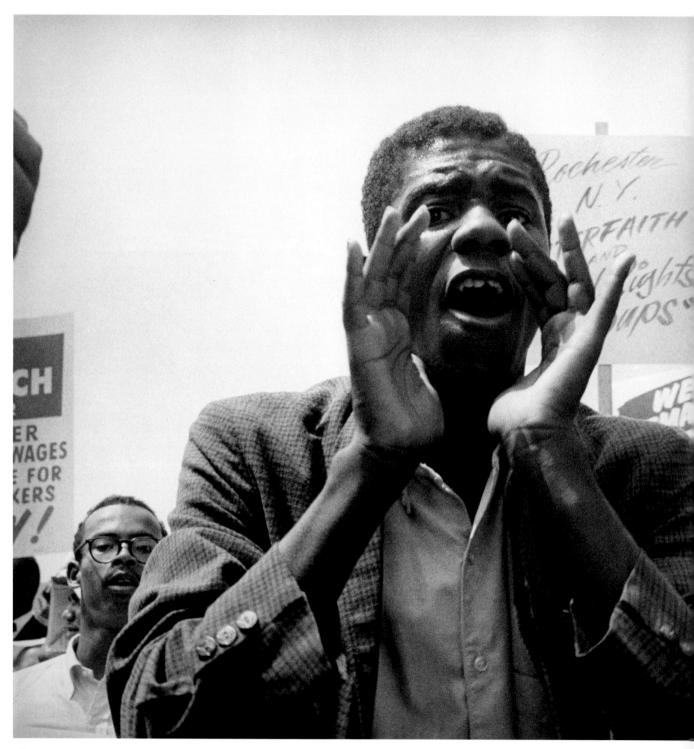

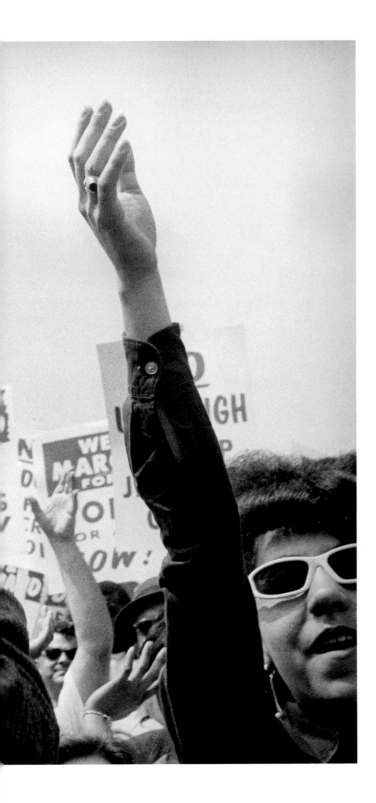

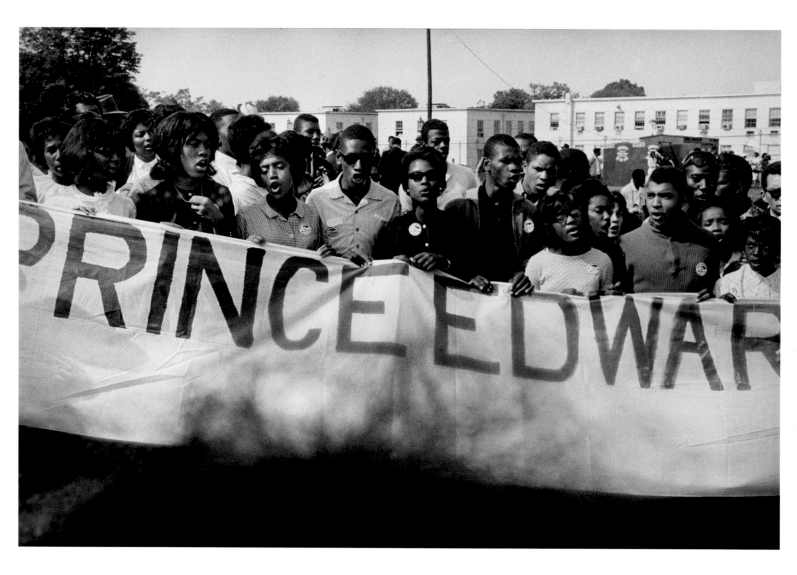

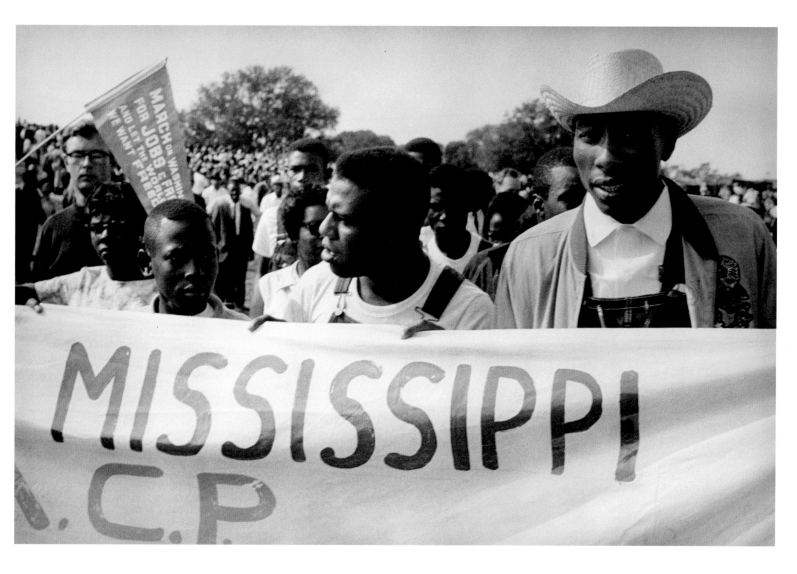

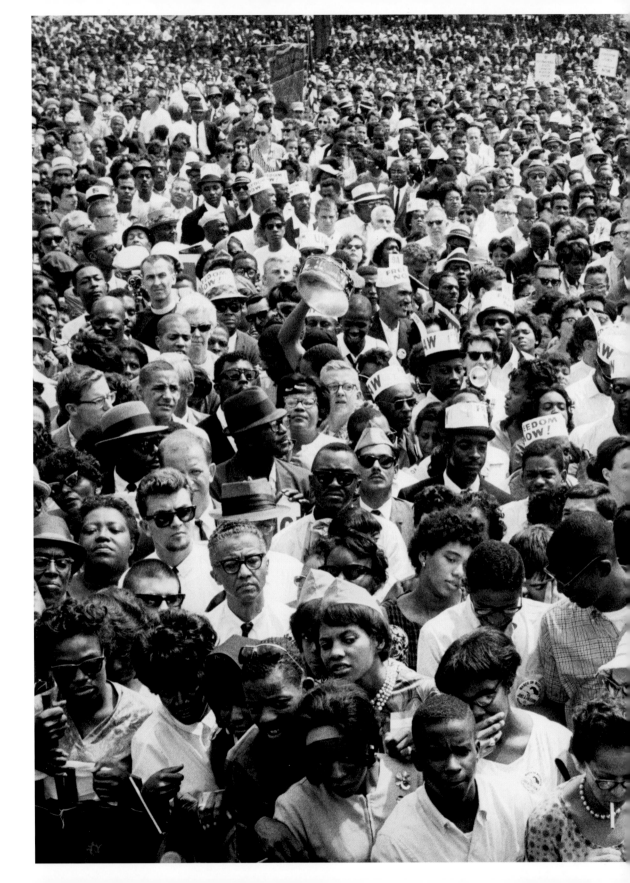

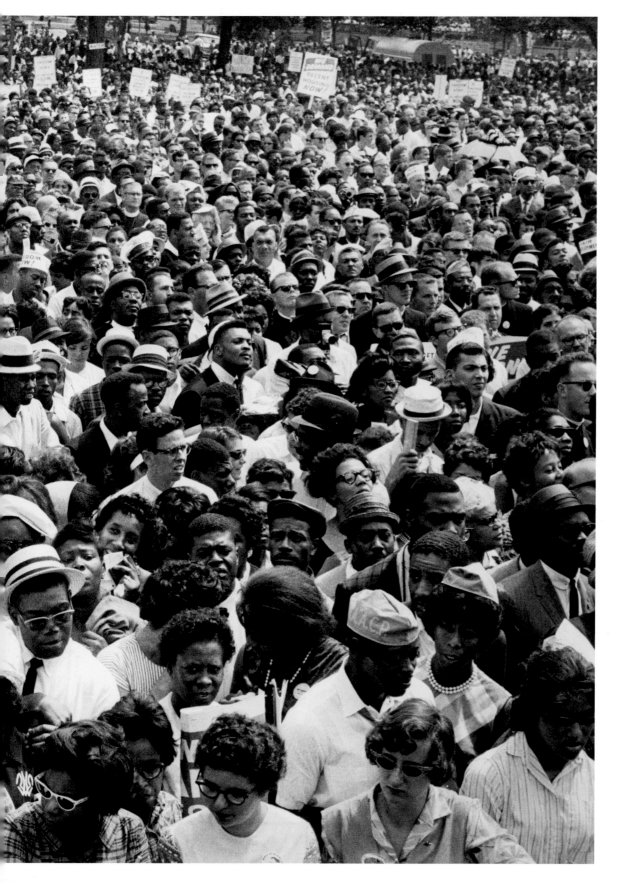

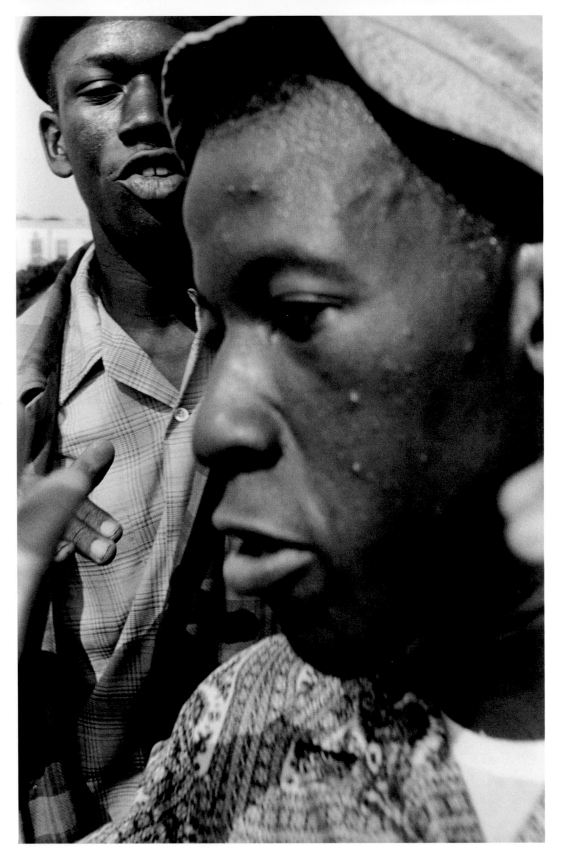

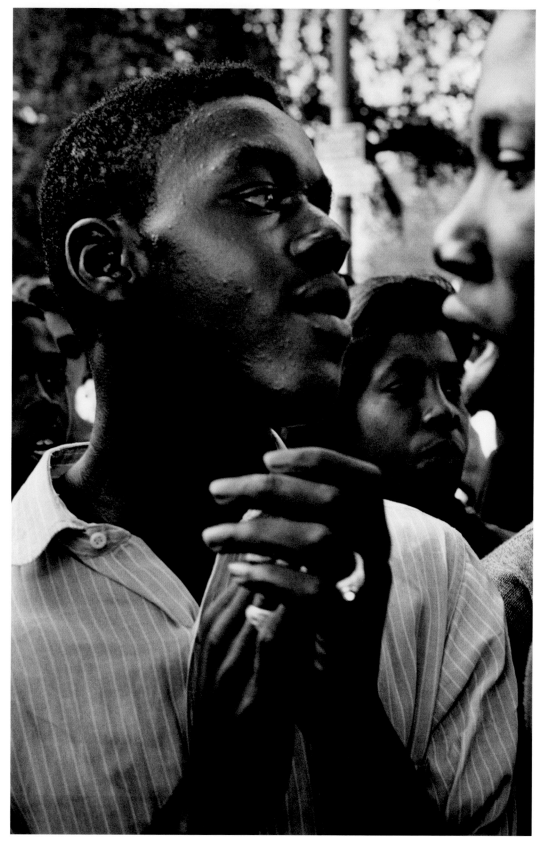

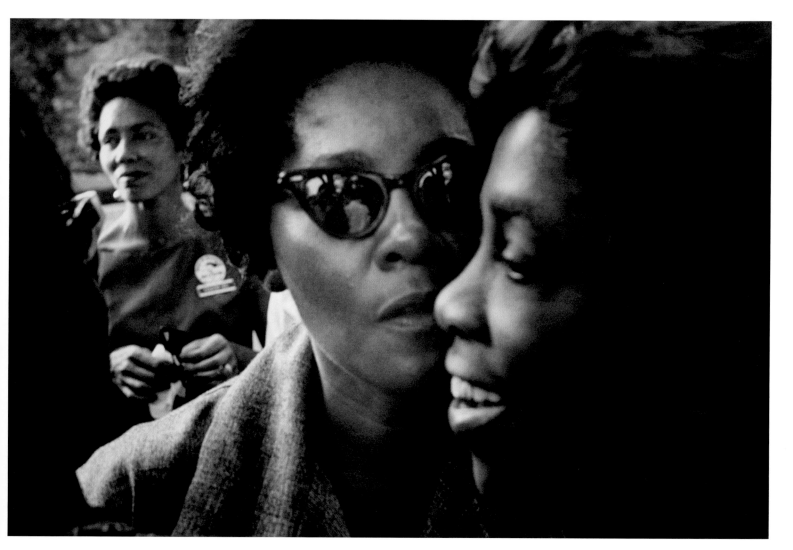

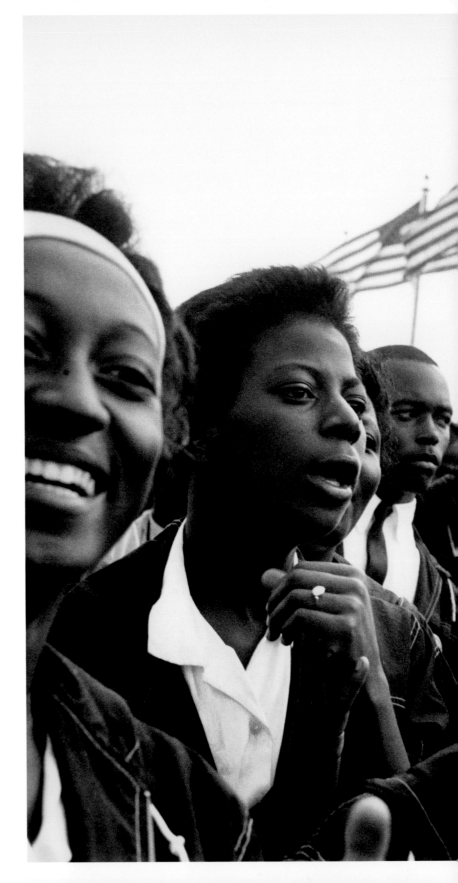

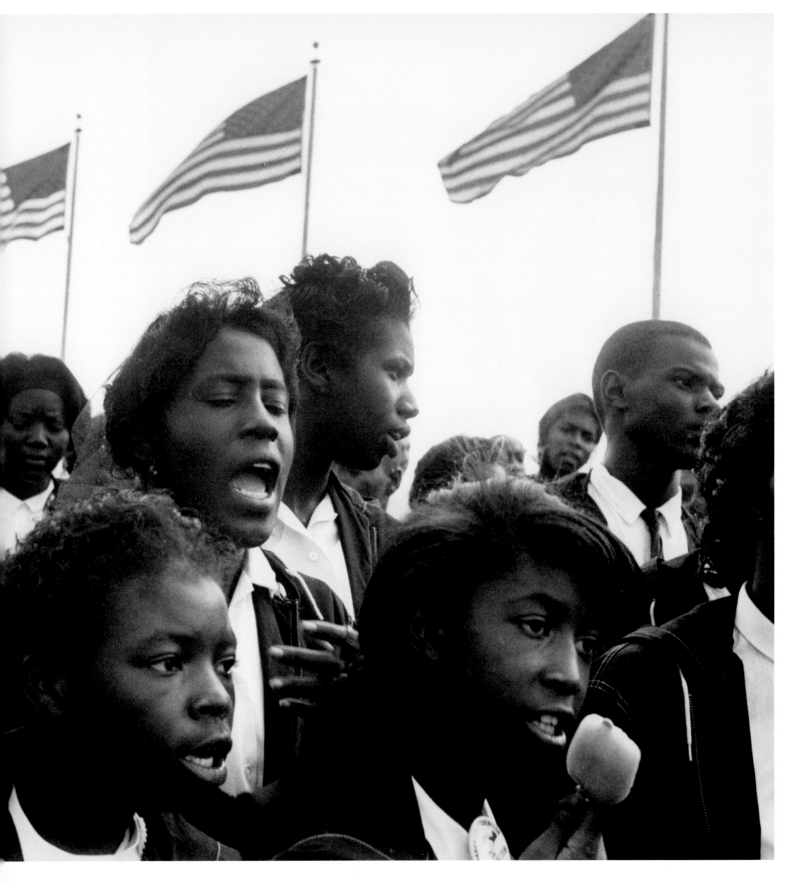

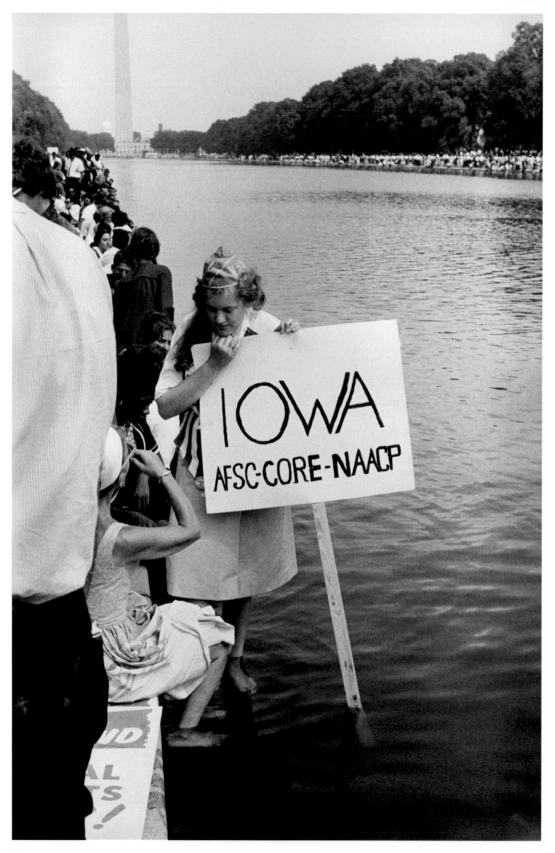

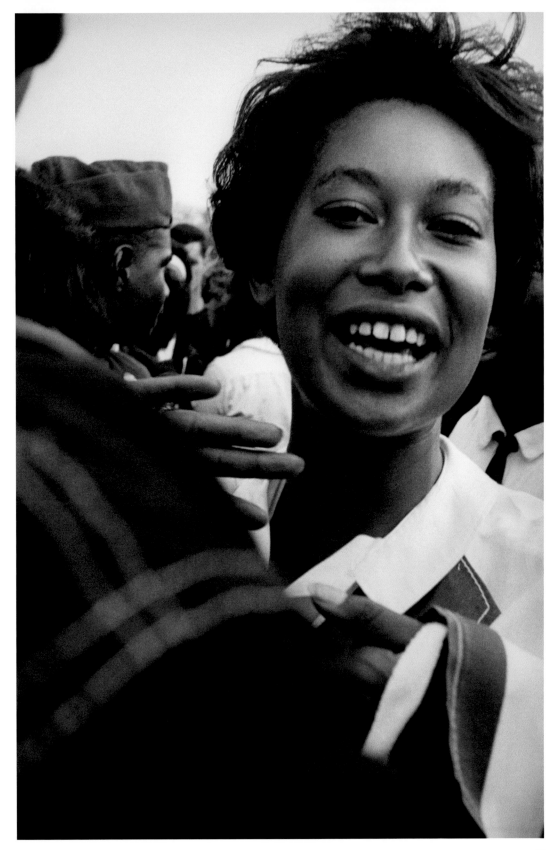

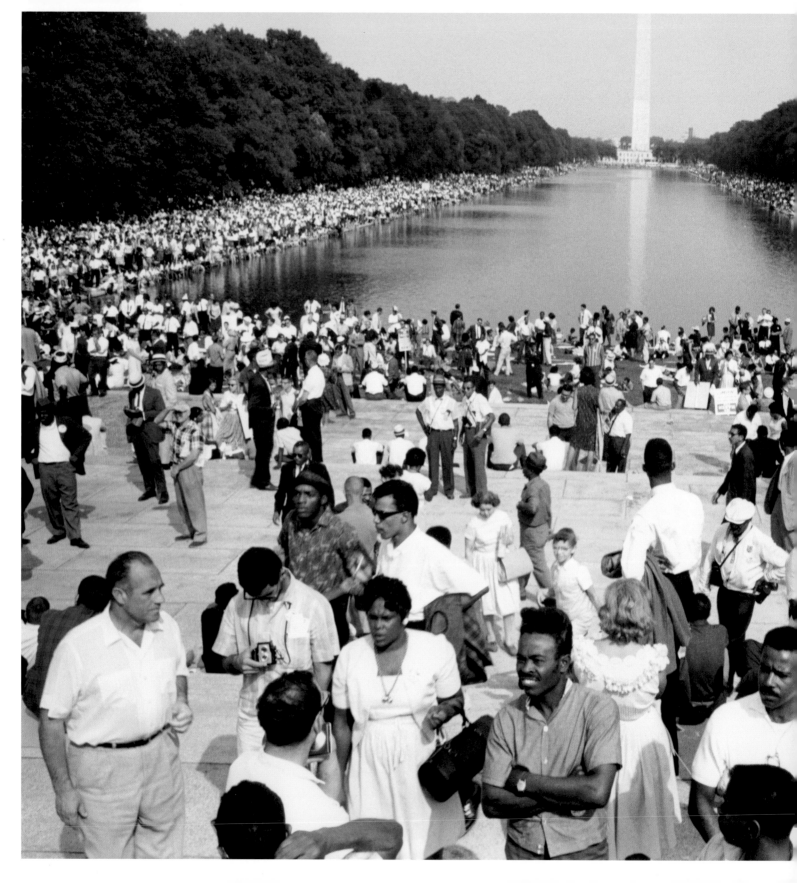

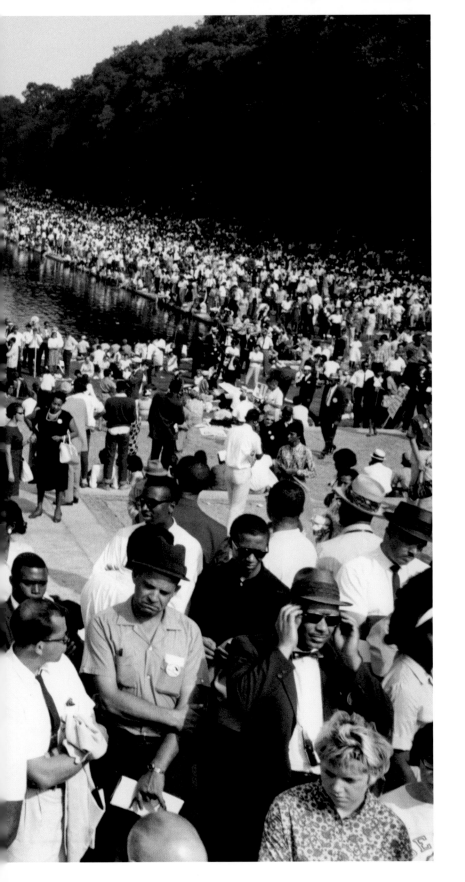

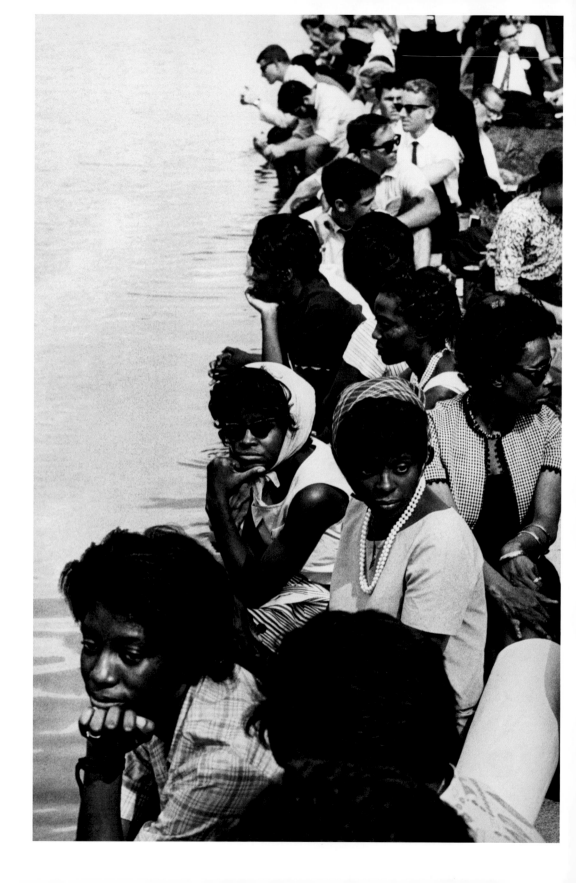

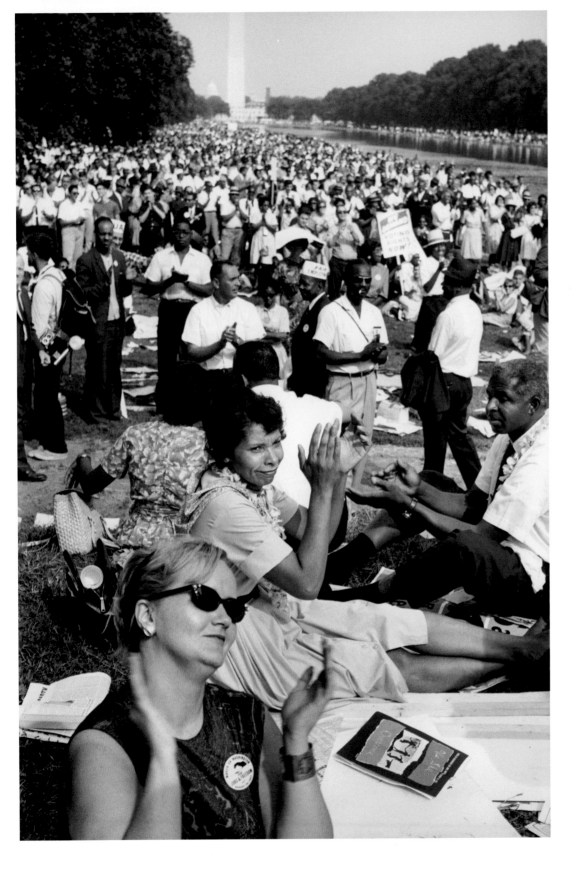

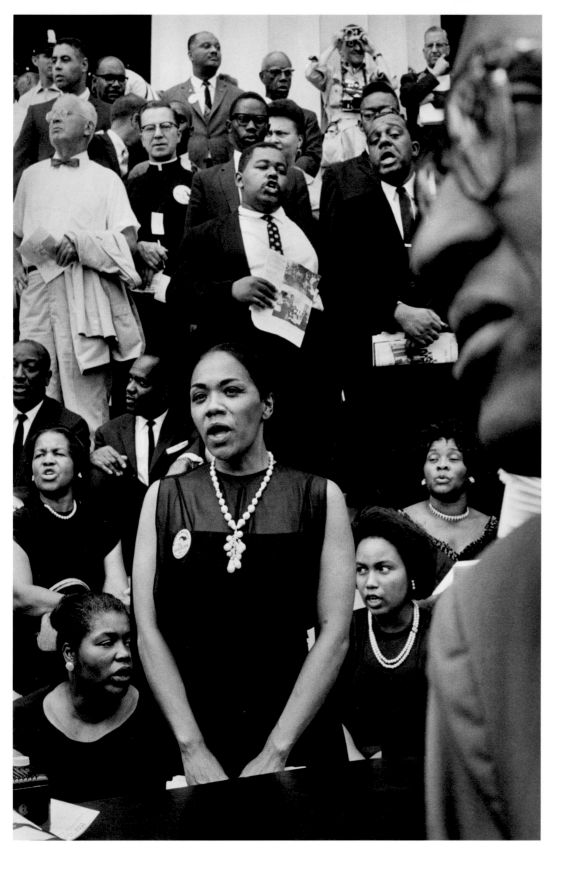

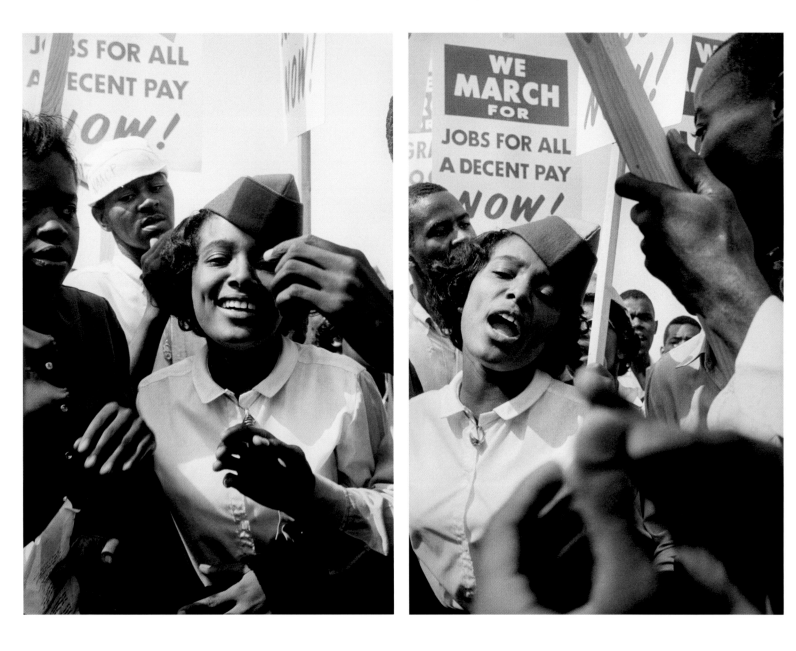

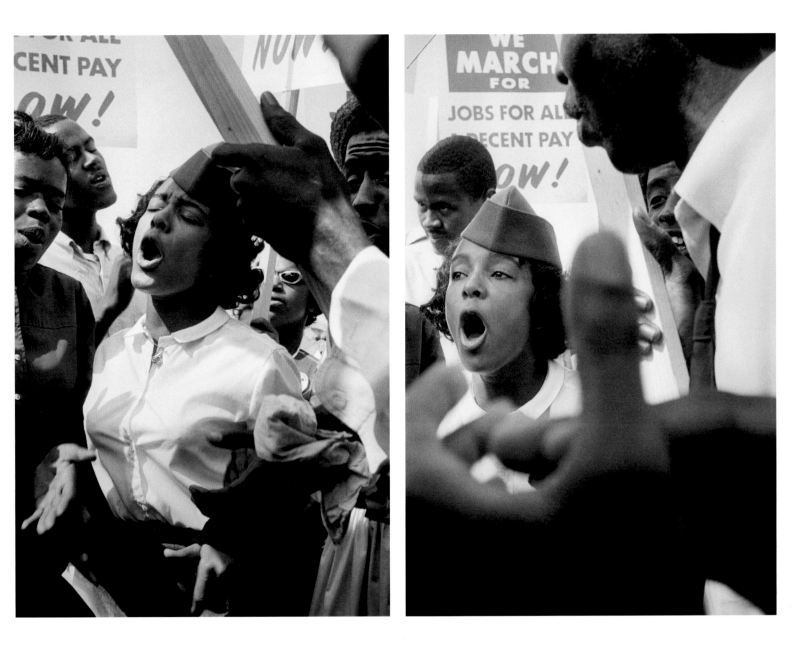

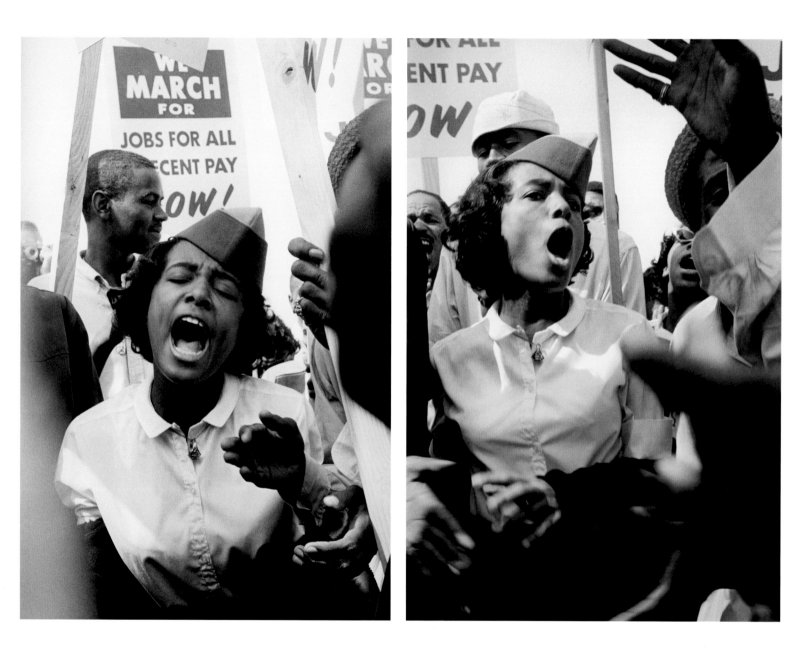

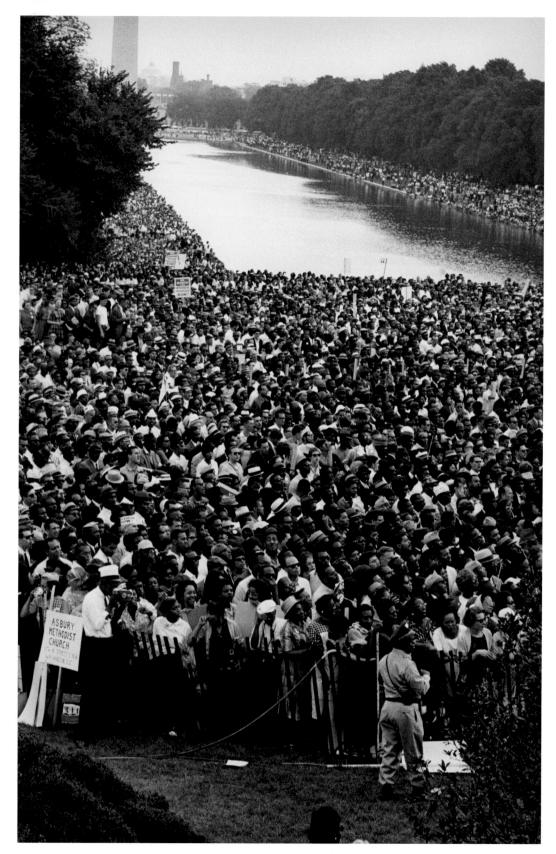

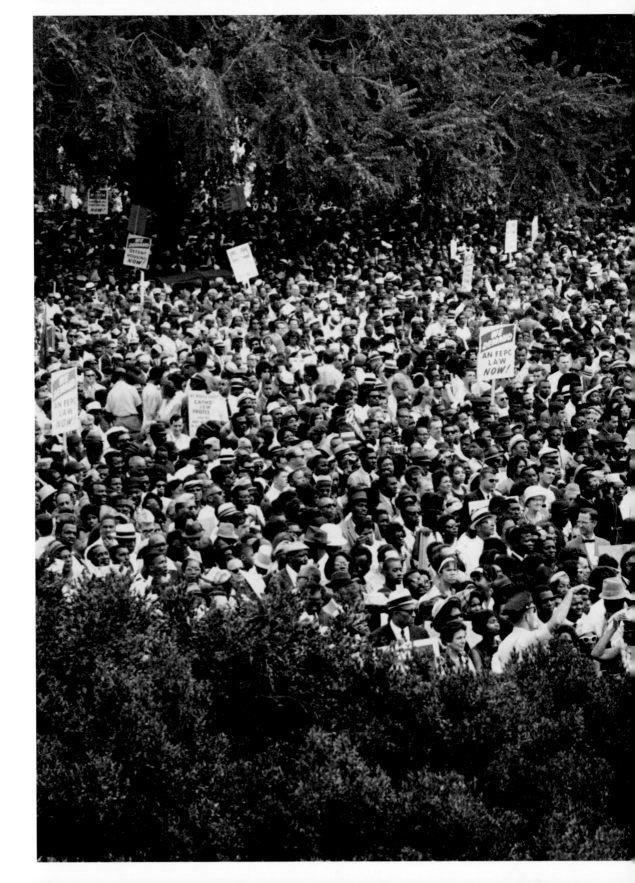

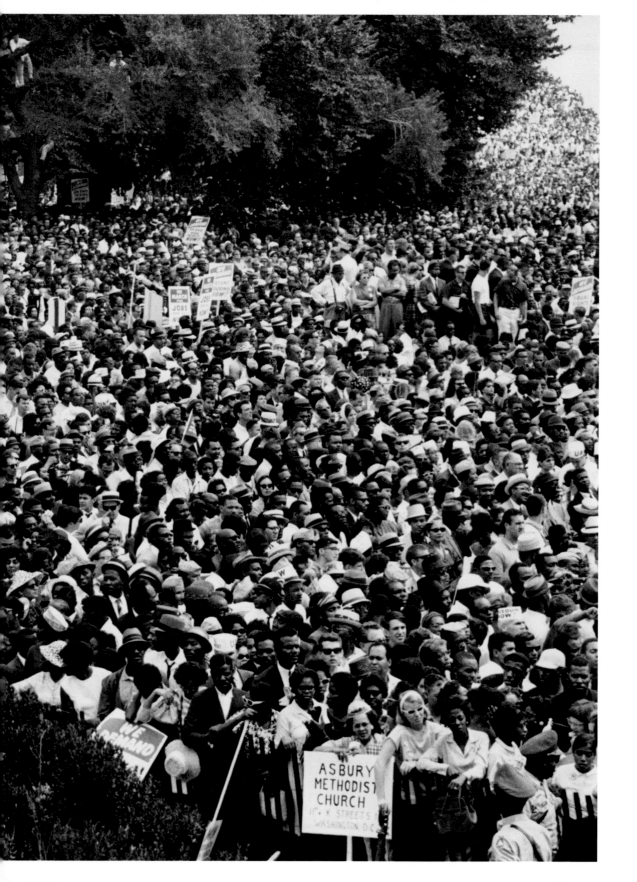

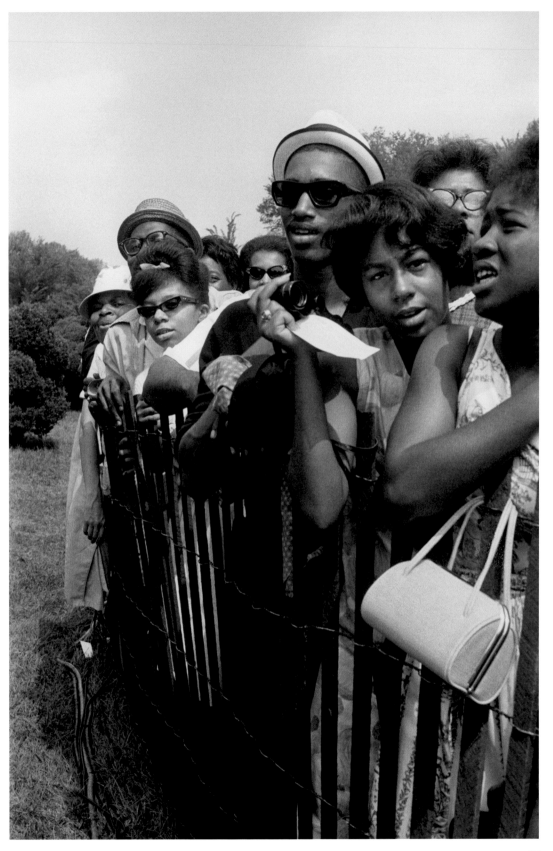

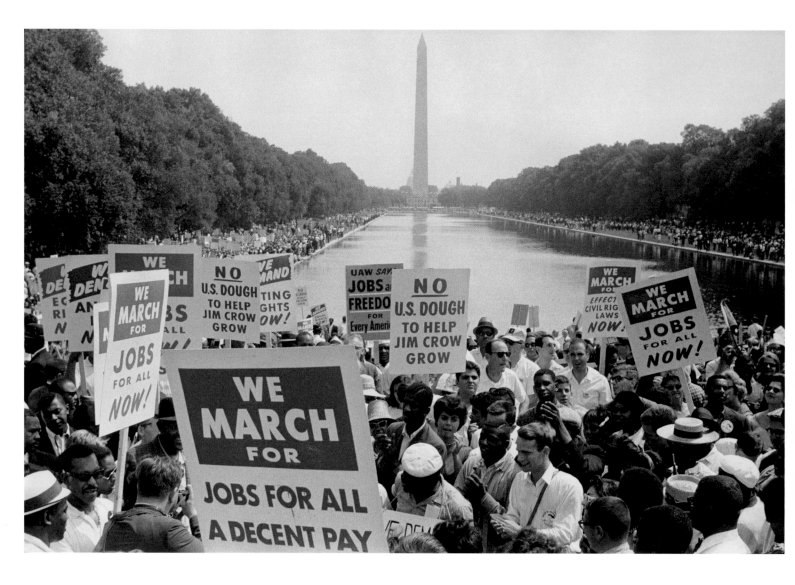

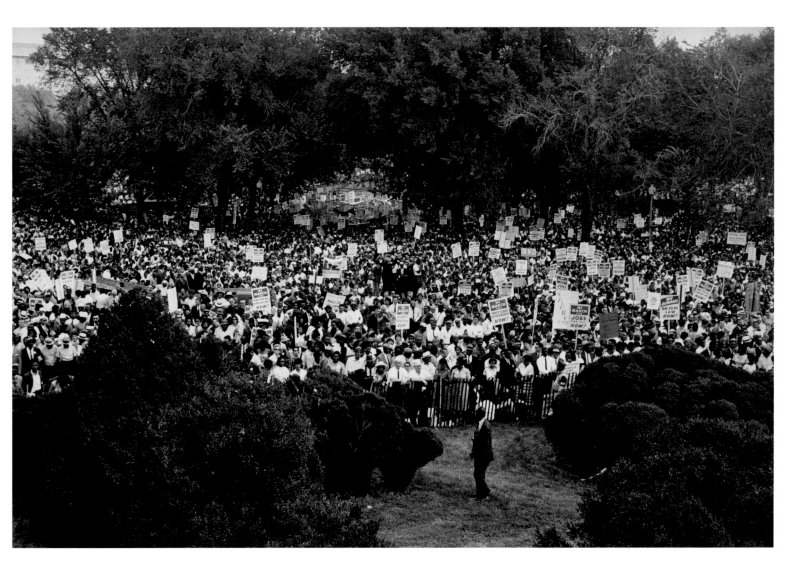

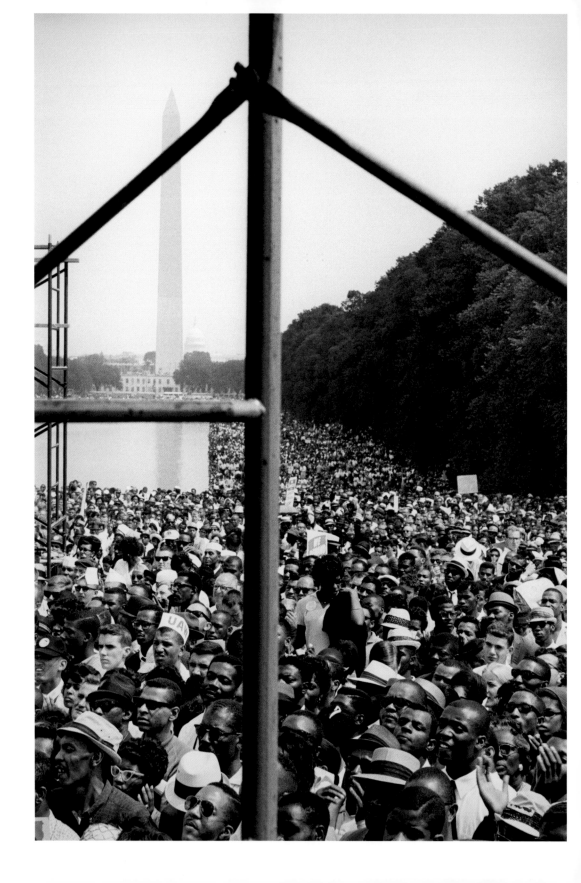

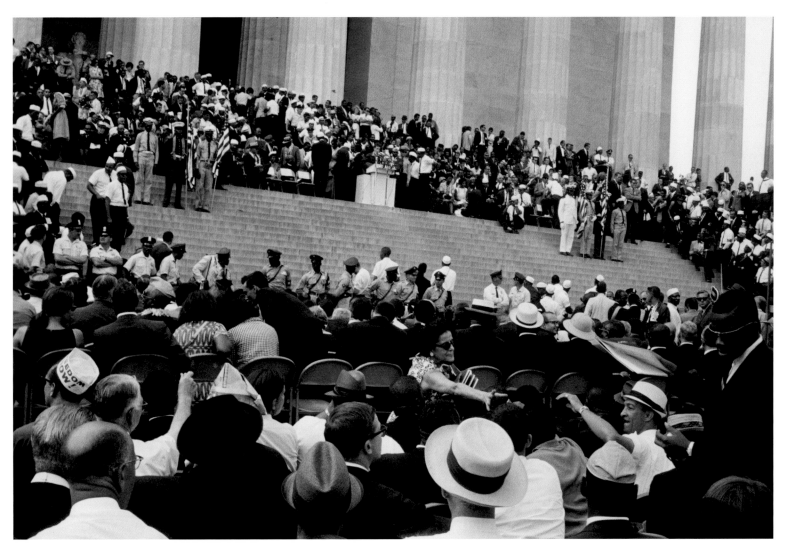

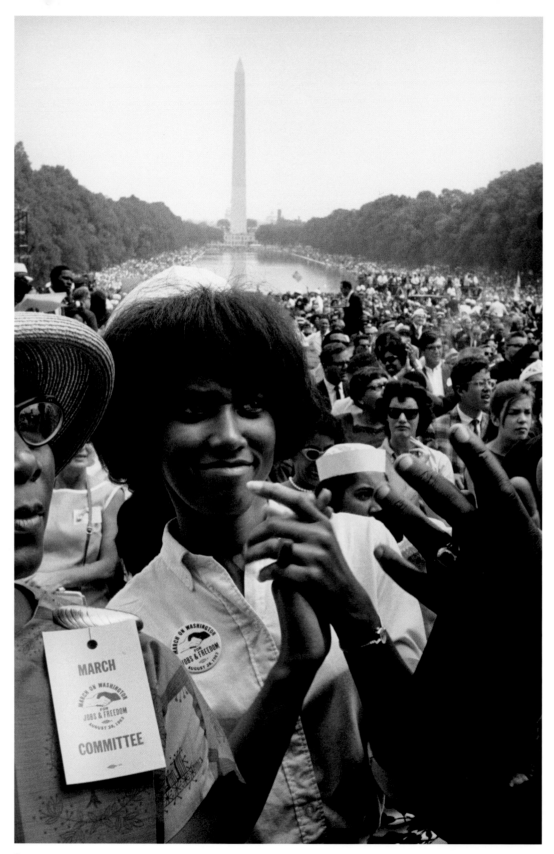

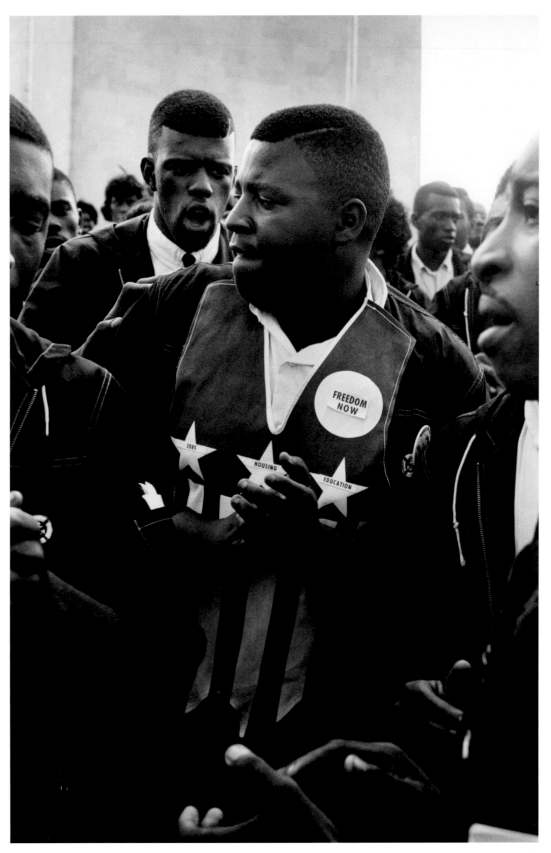

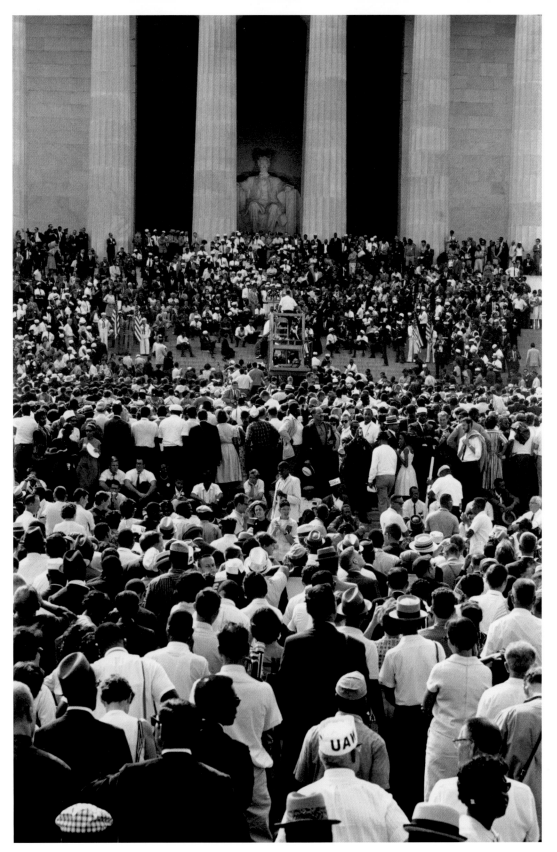

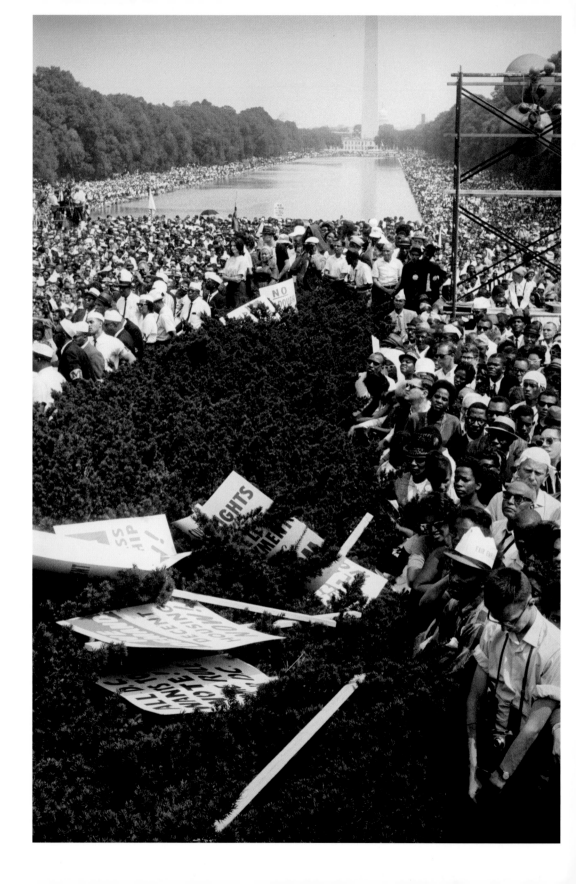

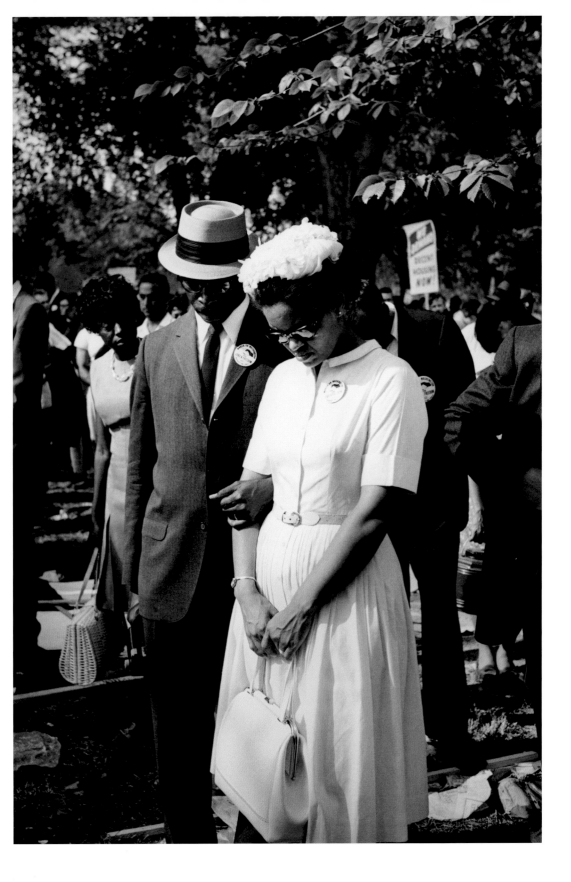

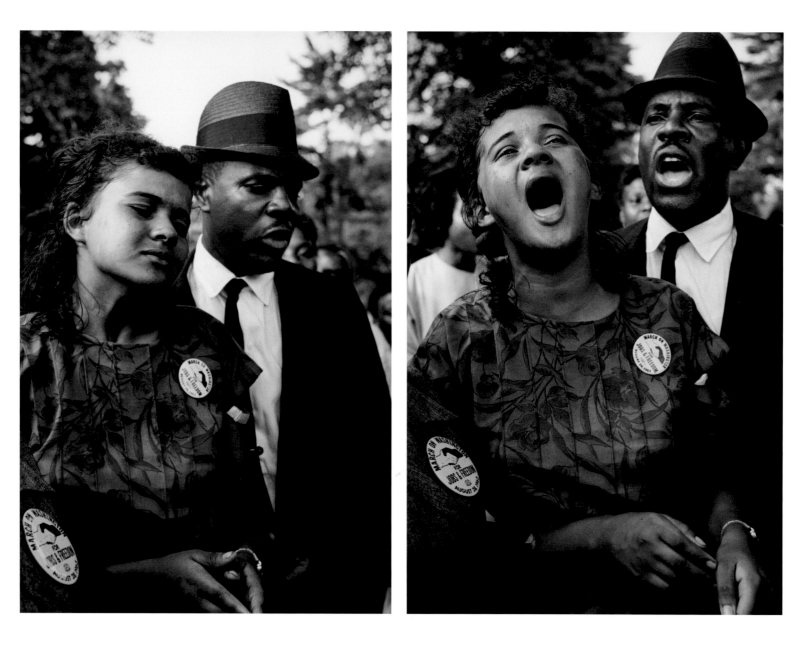

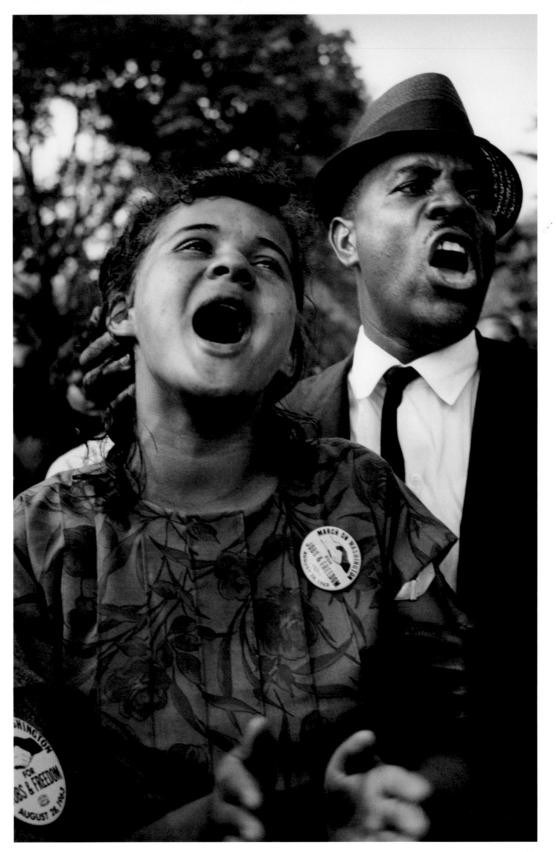

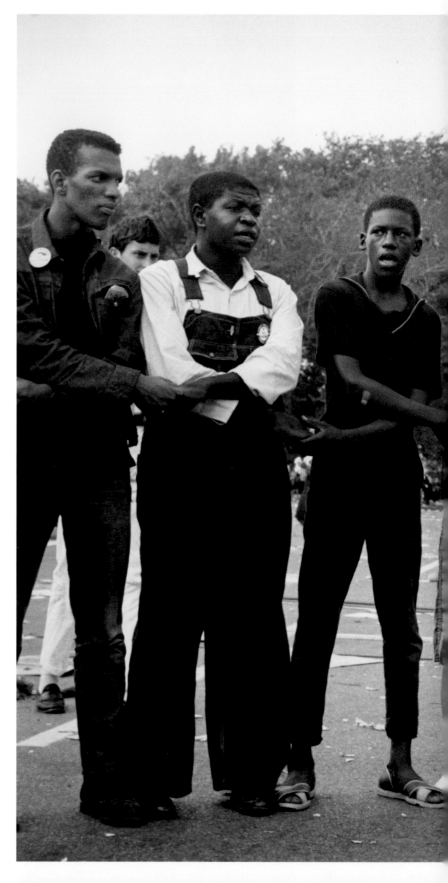

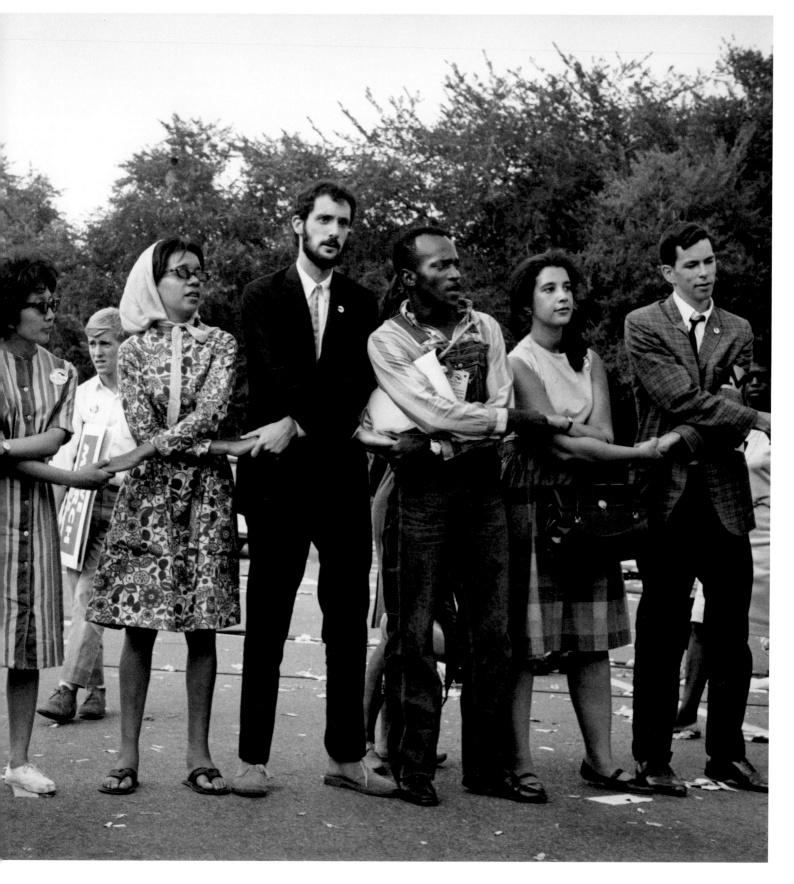

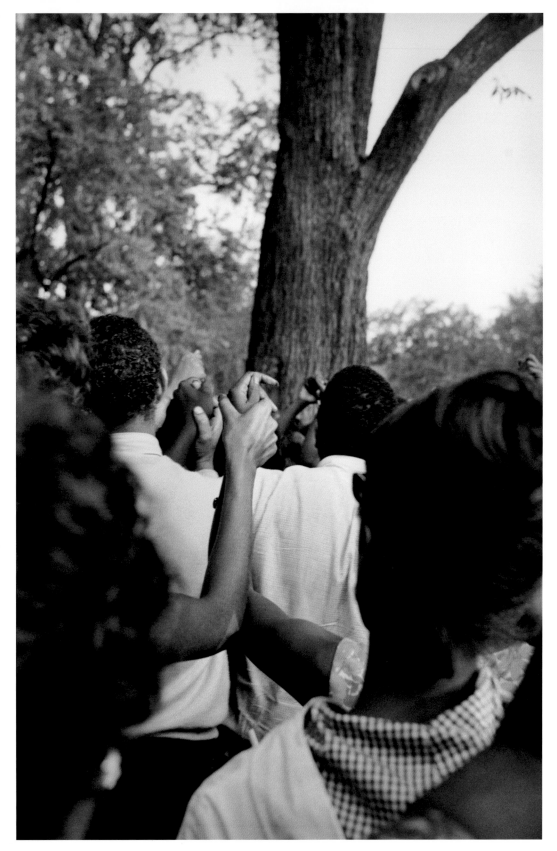

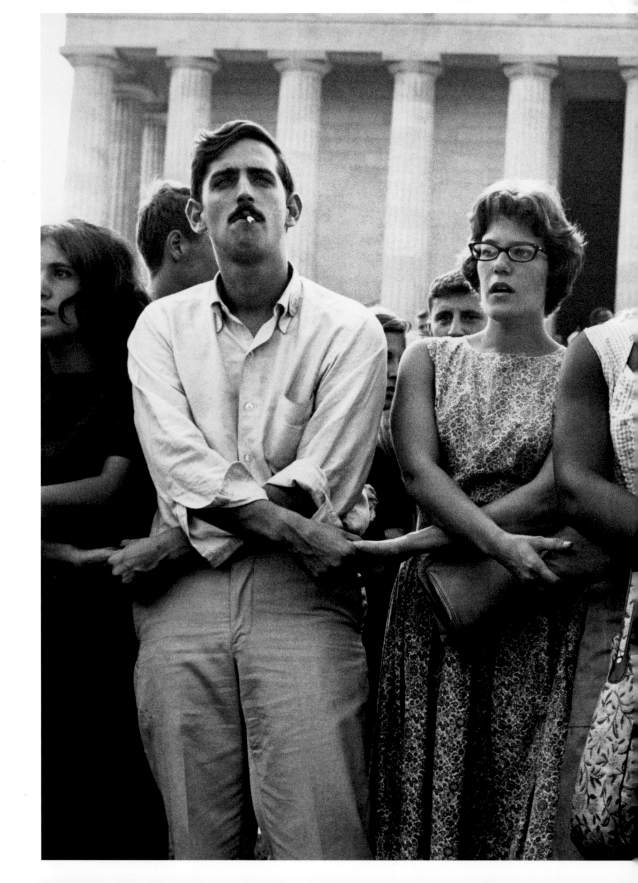

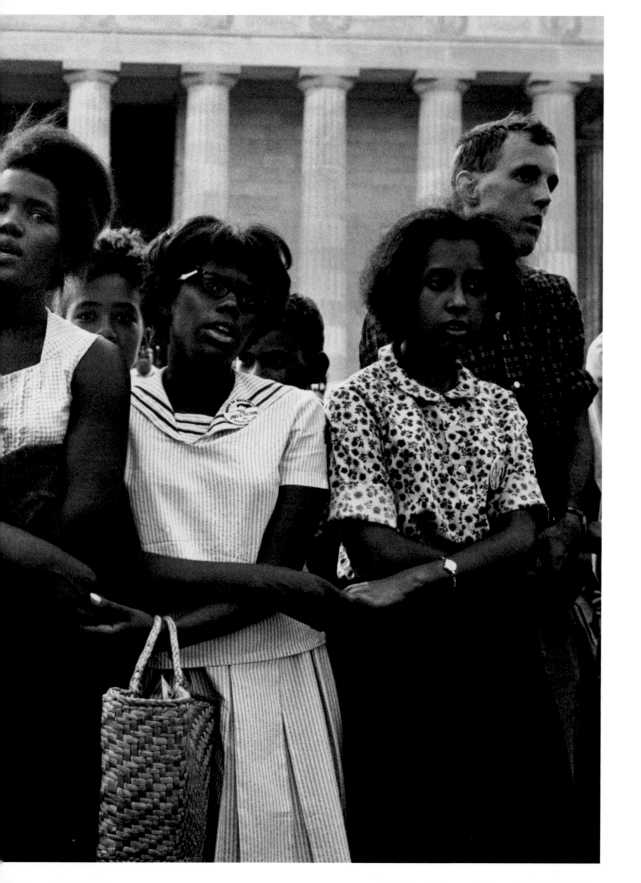

This Was the Day

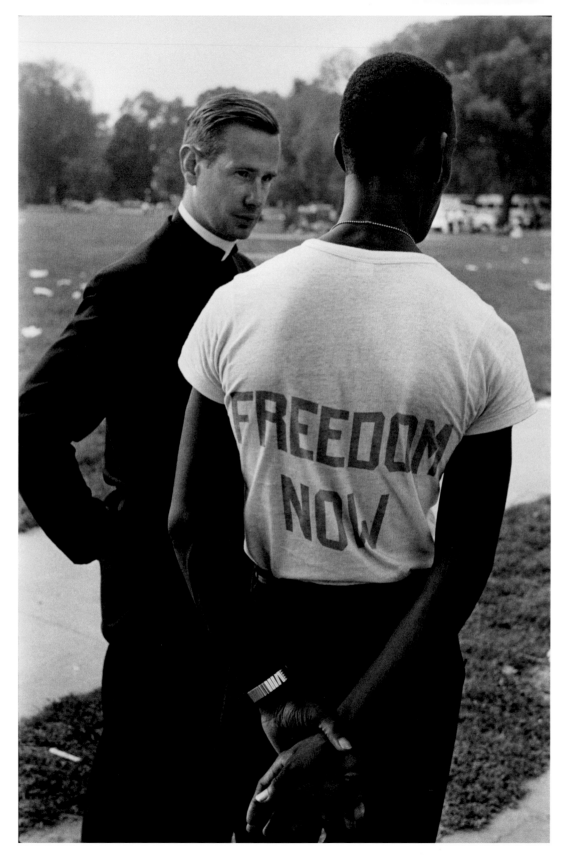

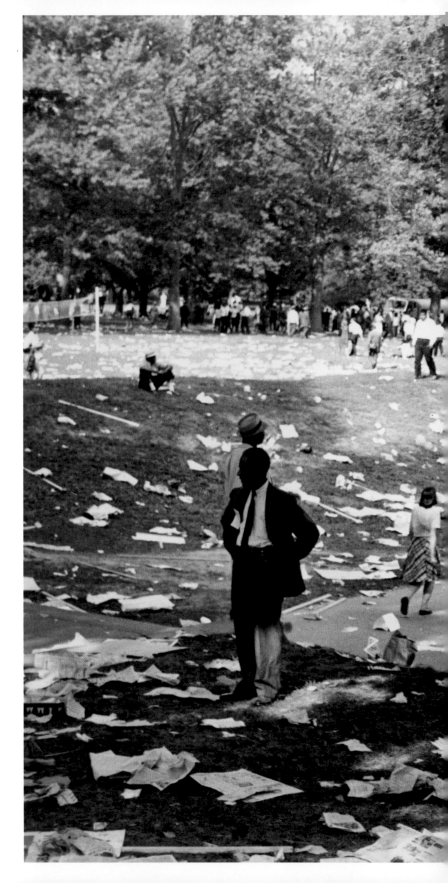

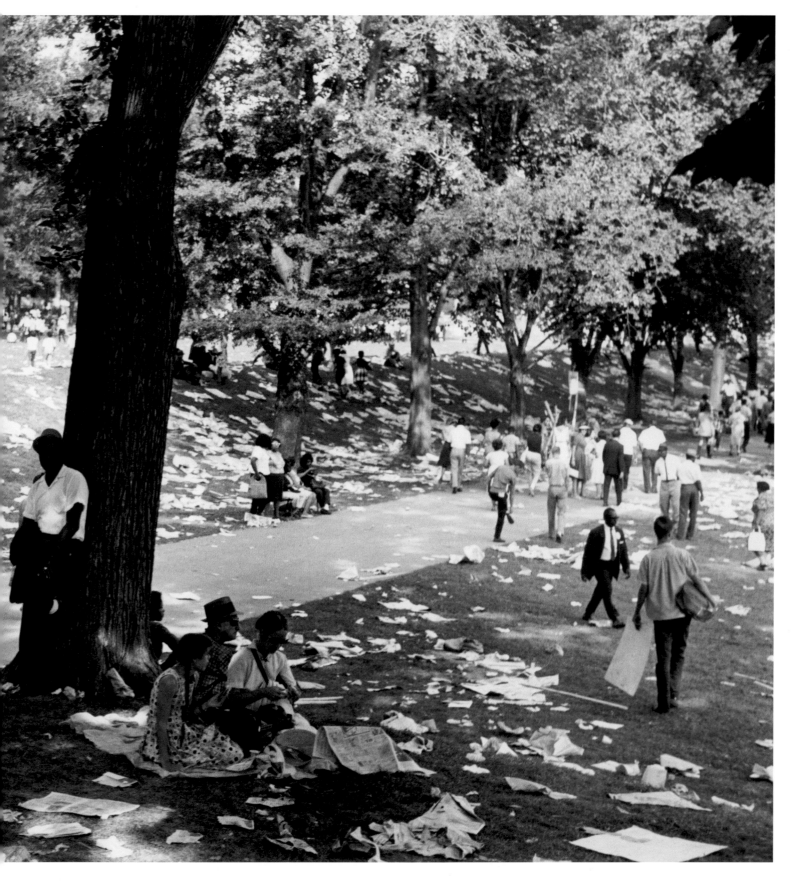

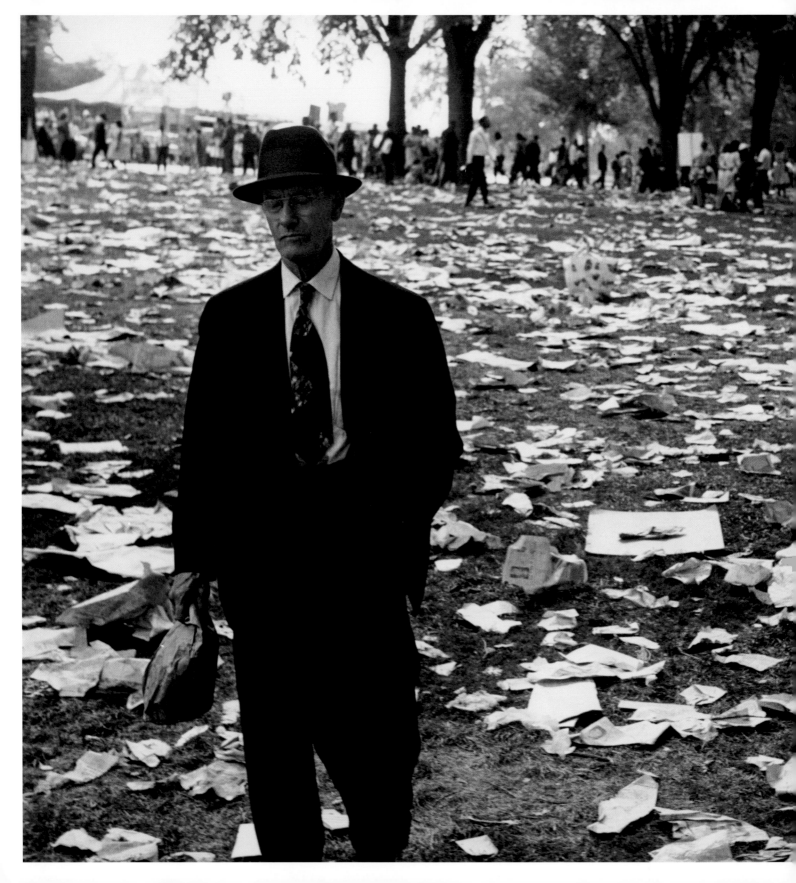

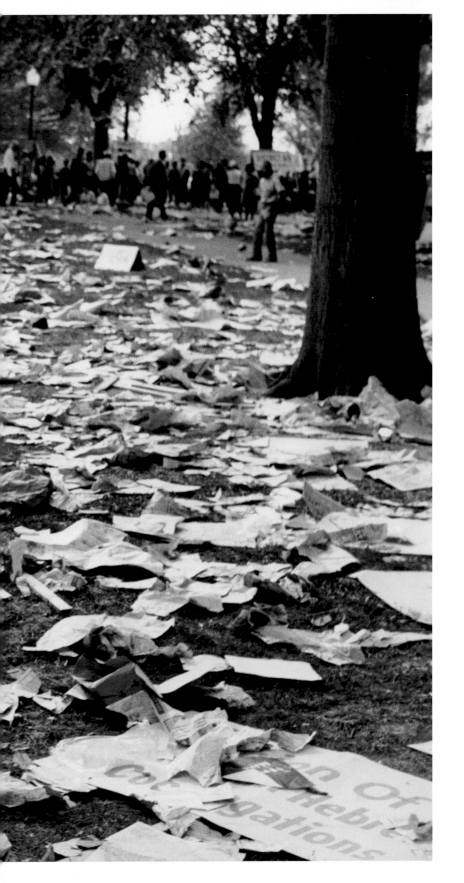

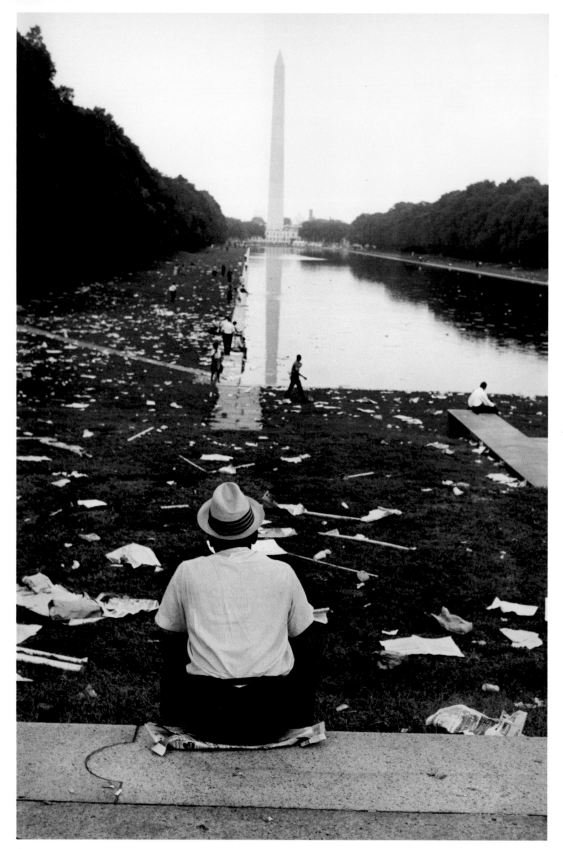

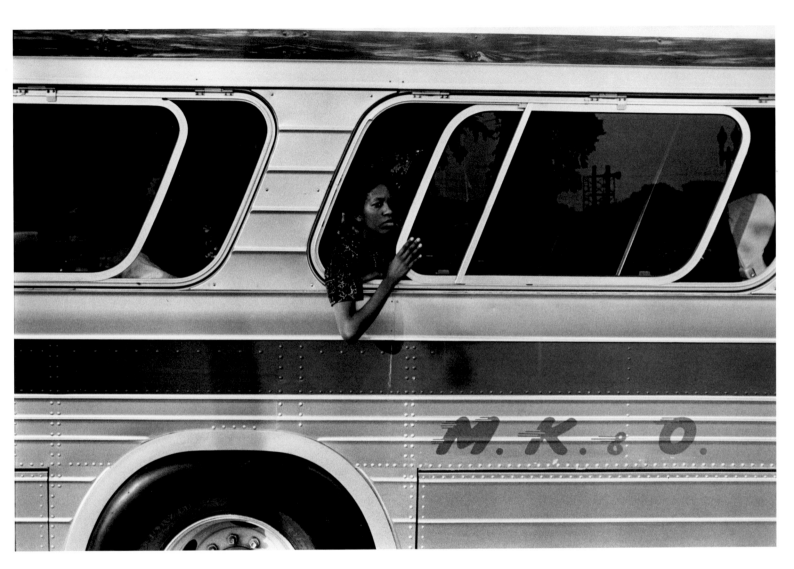

II

The Twentieth-Anniversary March

August 27, 1983

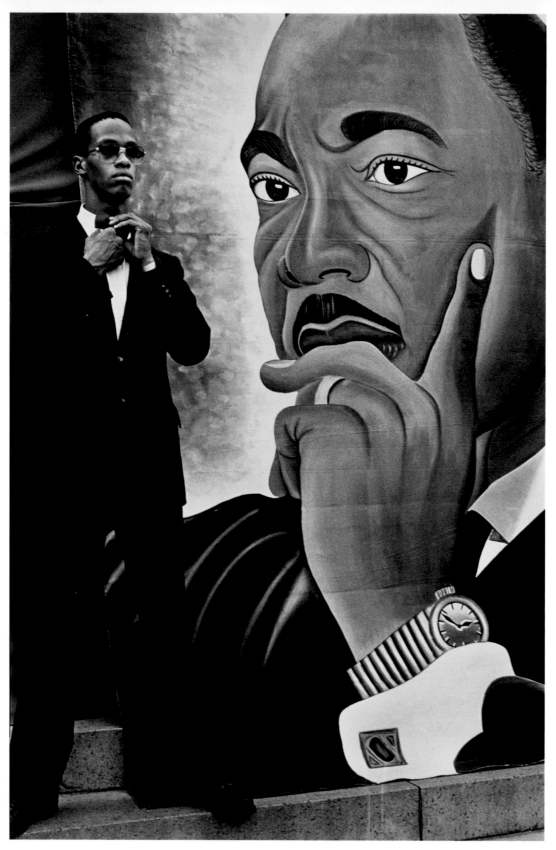

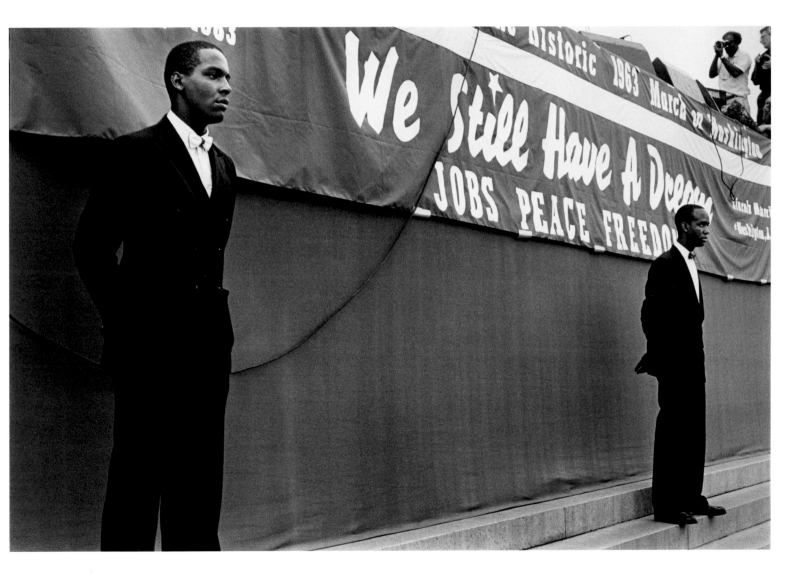

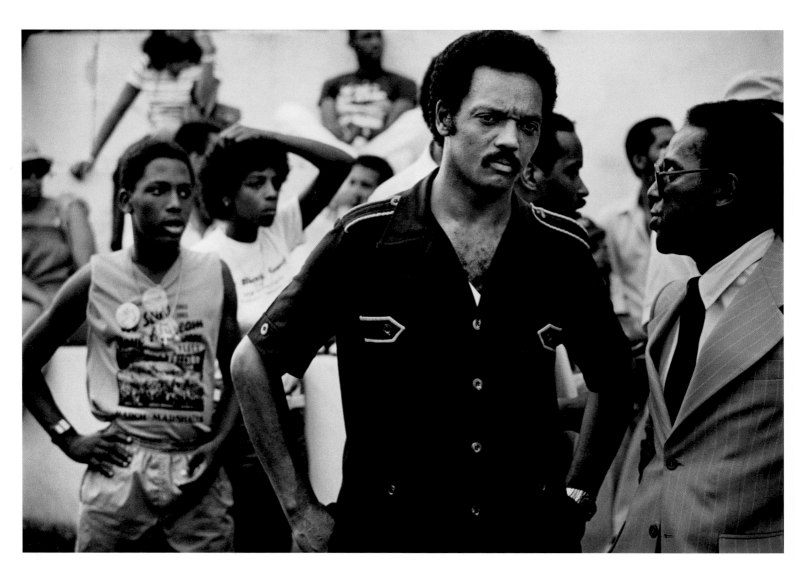

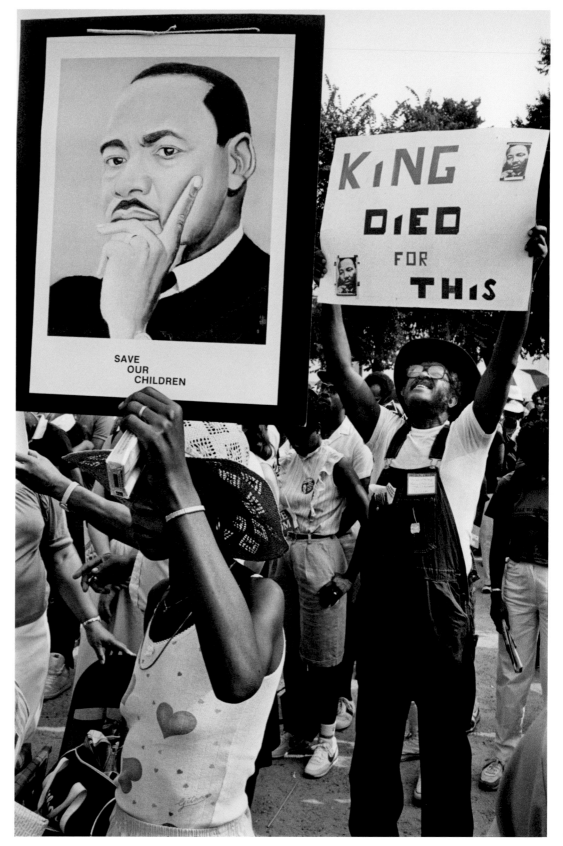

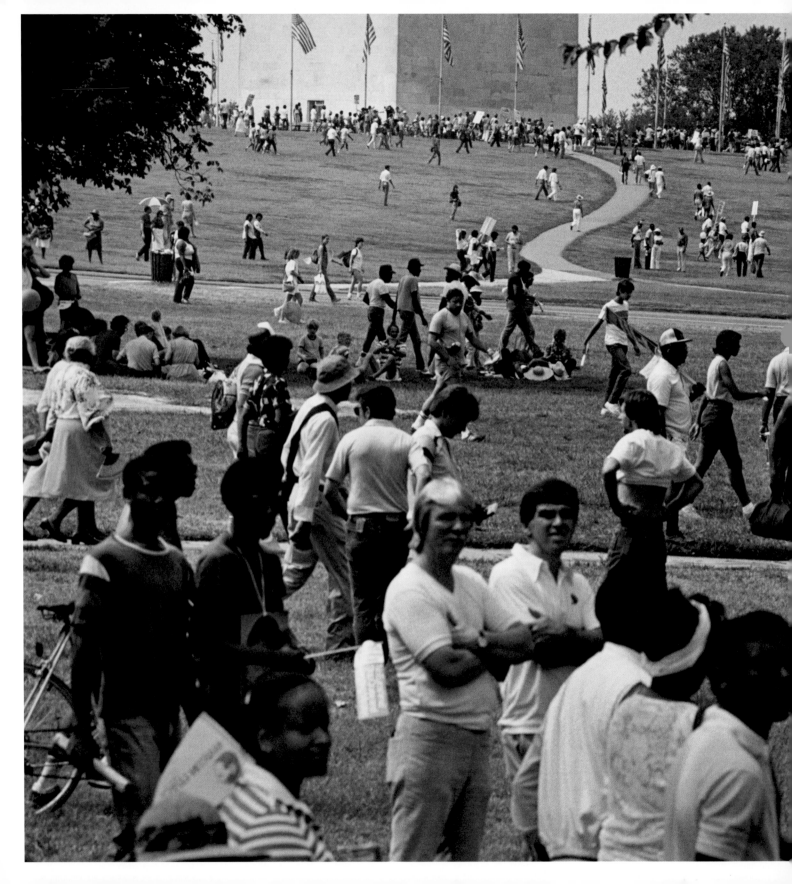

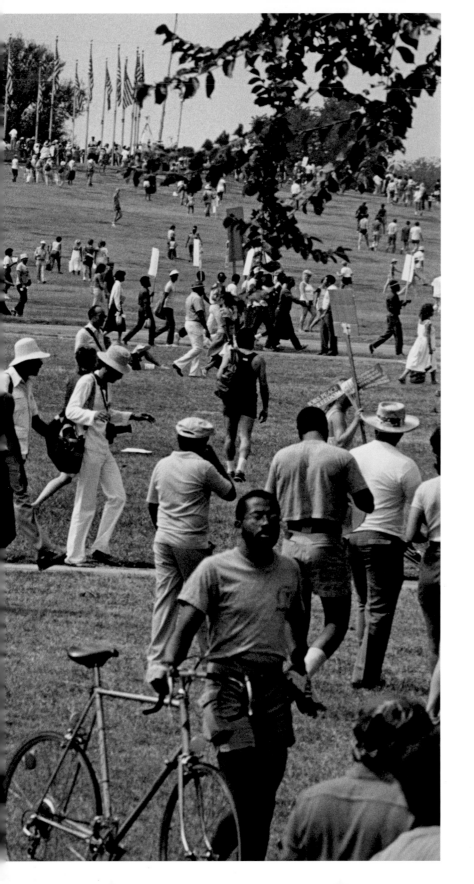

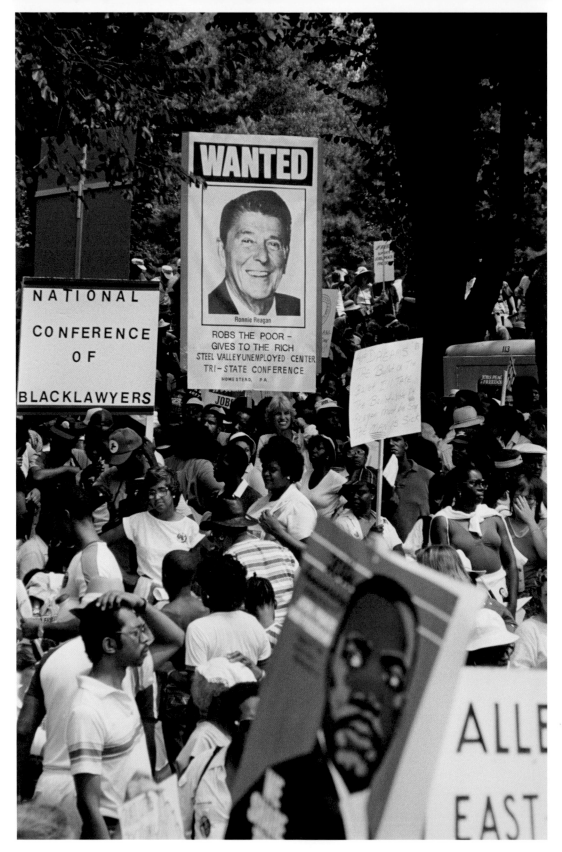

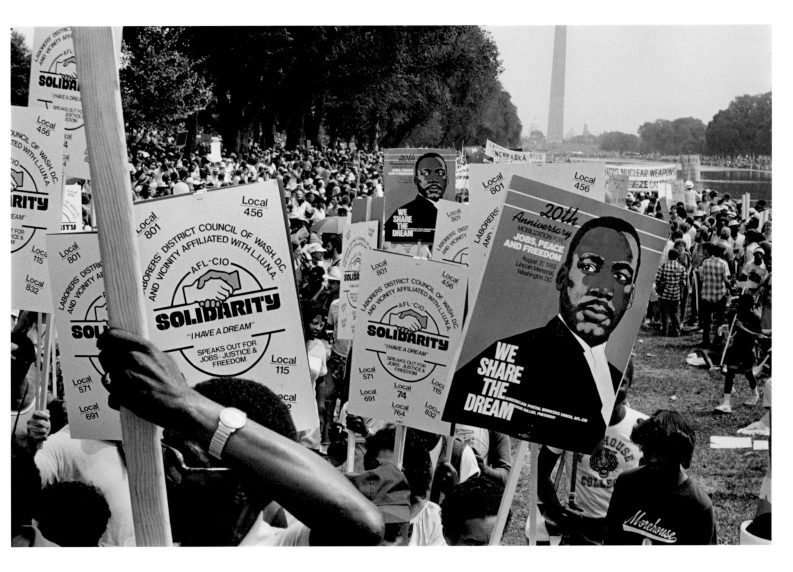

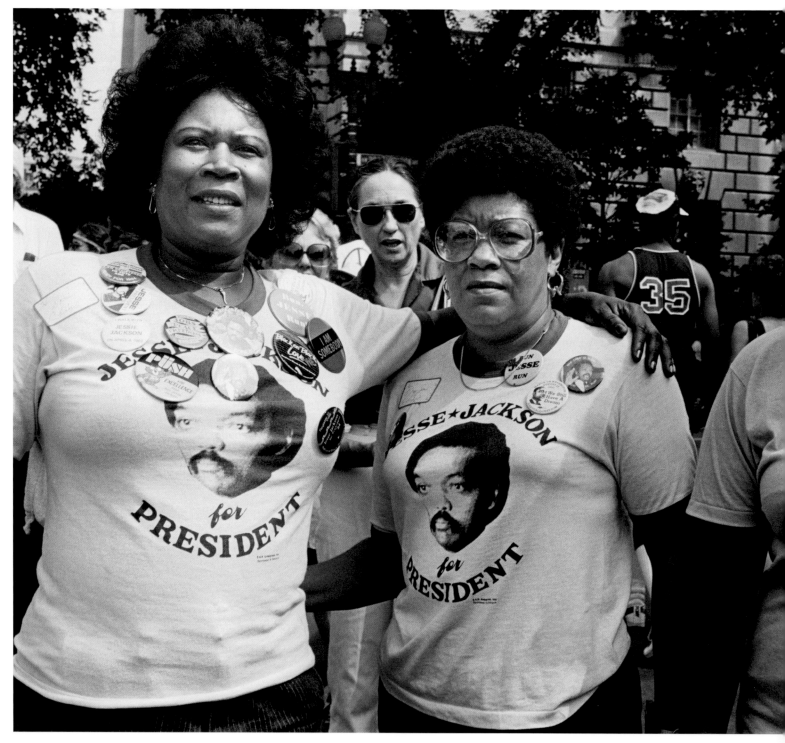

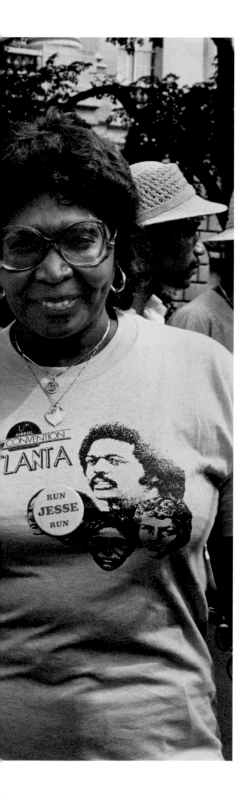

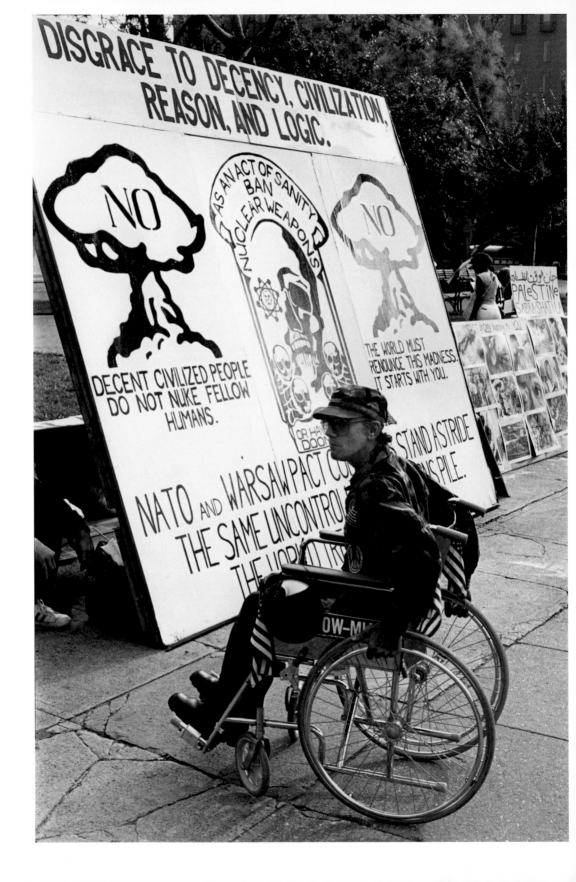

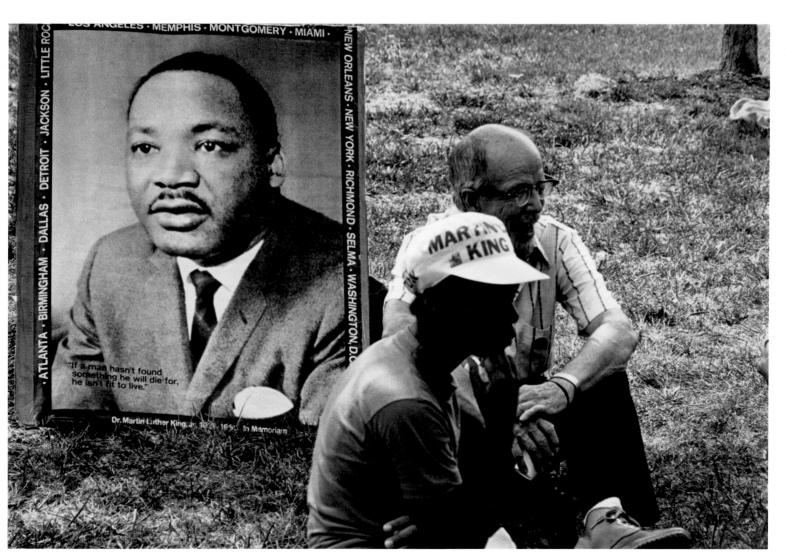

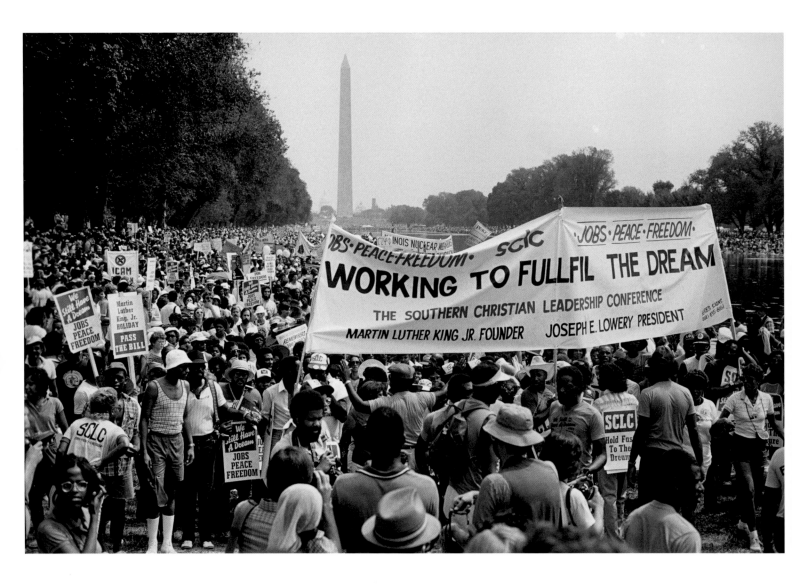

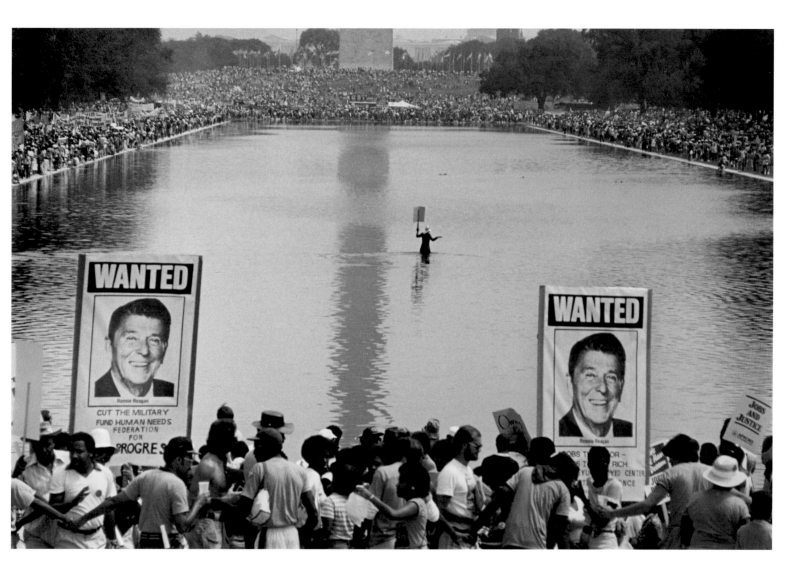

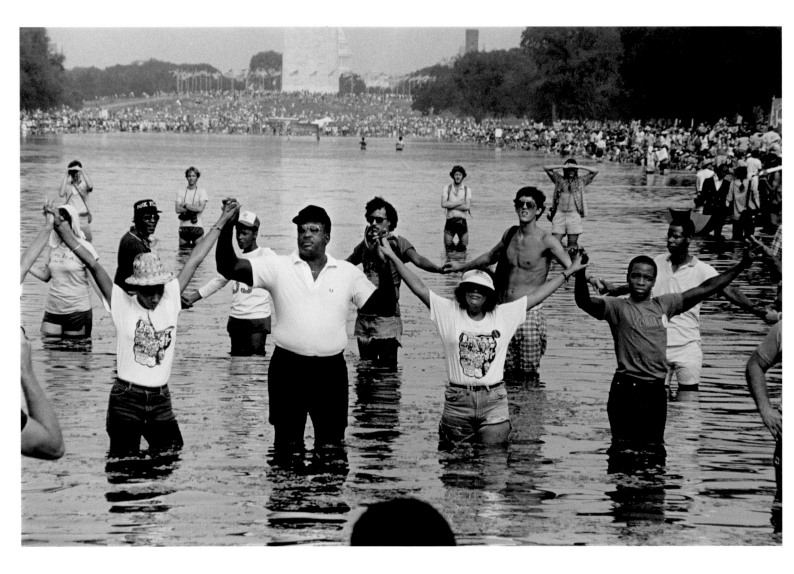

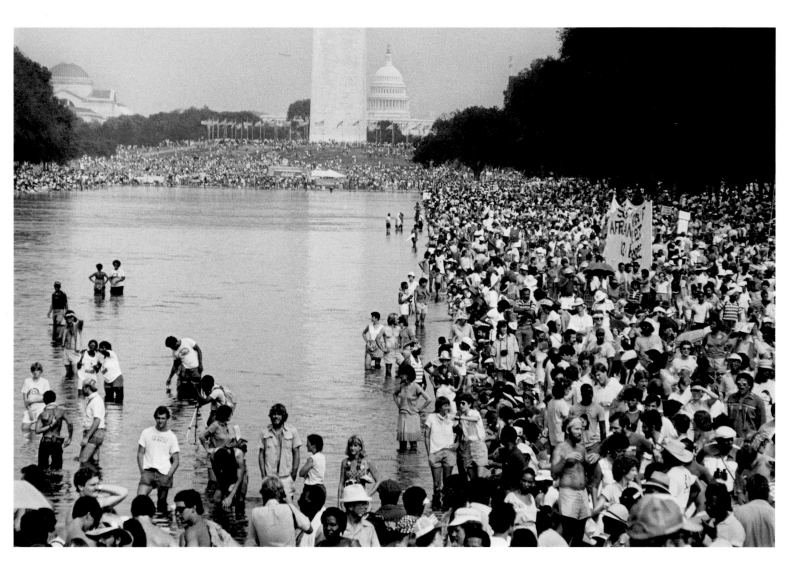

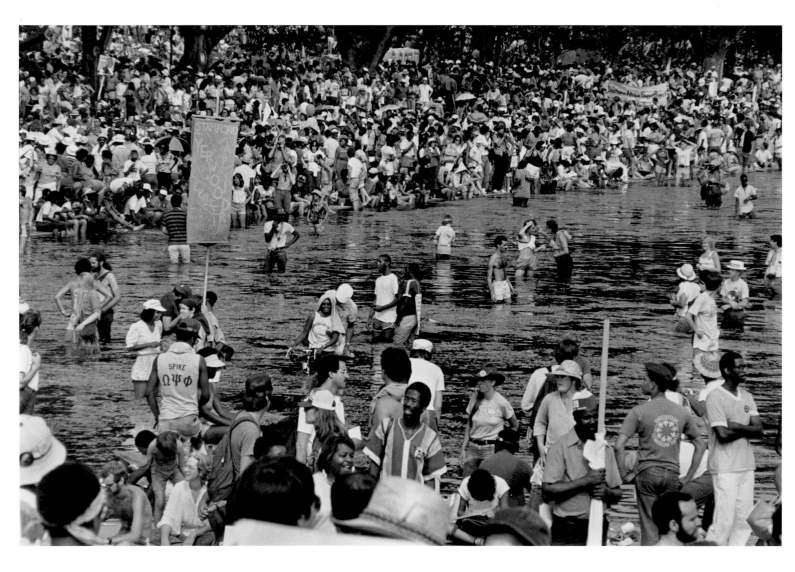

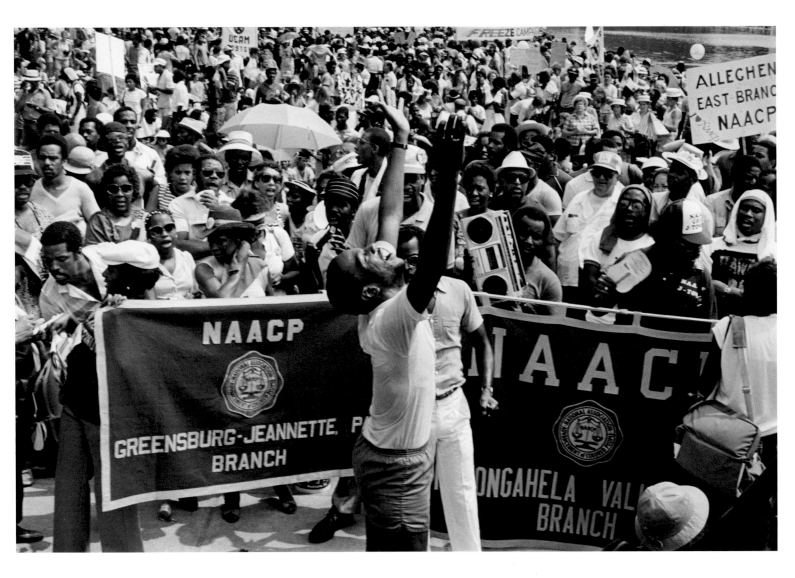

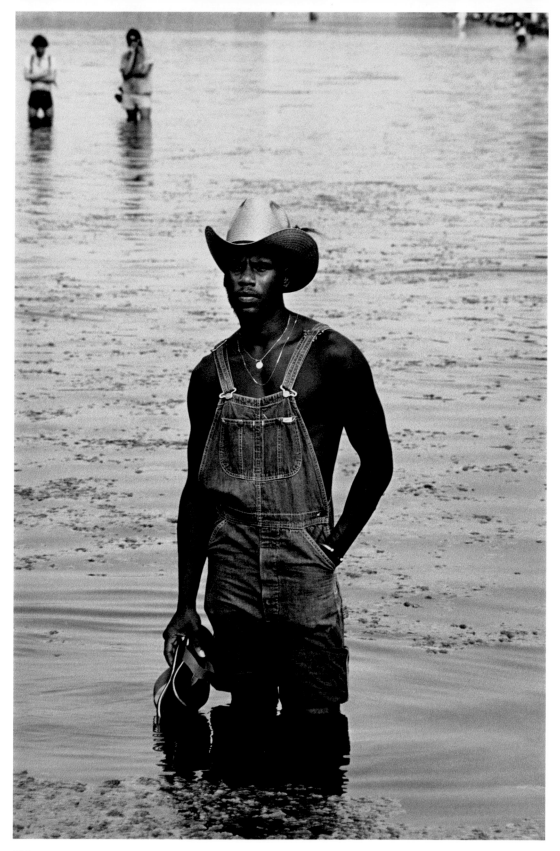

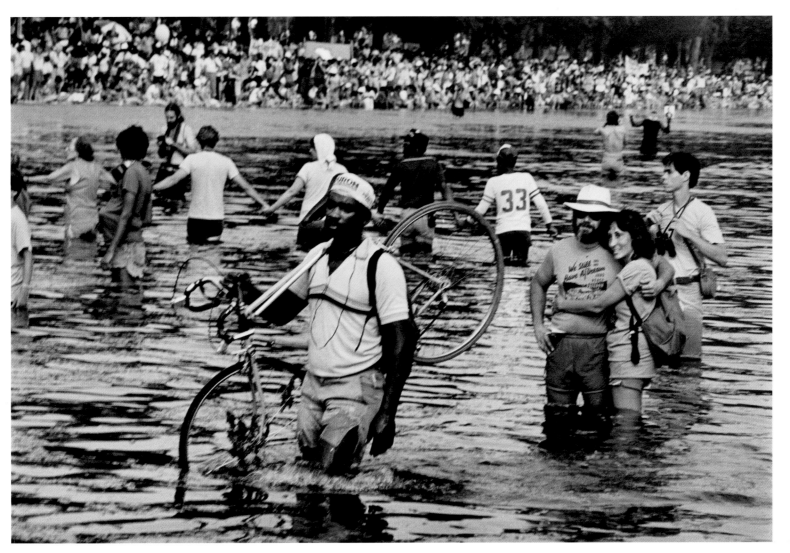

103

In Leonard Freed's Footsteps

Paul M. Farber

"When I photograph, I am always relating things to one another.
Photography shows the connection between things,
how they relate. . . .
Photographing is an emotional thing, a graceful thing.
Photography allows me to wander with a purpose."

—LEONARD FREED (1929–2006)

At daybreak on August 28, 1963, Leonard Freed arrived in Washington, D.C. He had returned home to Brooklyn earlier that summer from living abroad in Amsterdam with his German-born wife, Brigitte, and their infant daughter, Elke Susannah. The couple had packed their darkroom equipment from their apartment into their tiny Fiat 600, sailed with the car from Rotterdam to New York, and set up a workspace in the basement of Leonard's childhood home. Freed immediately got to work photographing the civil rights movement. He made an itinerary for himself on ruled notebook paper, where he detailed dozens of potential photo shoots, including protests, street festivals, and beauty pageants. For August 27–29 he wrote, "Negro March on Washington."[1] The day before the event, Leonard and Brigitte drove south and slept in a campsite outside of D.C. They awoke at 5:00 A.M. and drove into the city several hours ahead of the official start of the march.

Freed began his day on the periphery of the National Mall, capturing scenes on his handheld Leica camera. He walked from the base of the Washington Monument, where he photographed stacks of soon-to-be-dispersed protest signs (pages 16–17), to the White House fences, to the streets surrounding Ford's Theatre. Several blocks from the epicenter of the march, Freed captured some of his first photographs of the day under a sign that read HOUSE WHERE LINCOLN DIED (pages 14, 15). Freed made photographs of passersby as they crossed one another's paths by the famed theater. He envisioned this foot traffic as a prelude to the later gathering by the Lincoln Memorial. On that day Freed was tapping into the deeper currents of historical memory while citizens from a nation afflicted by internal division and racial trauma were gathering at its most hallowed grounds to transform it.

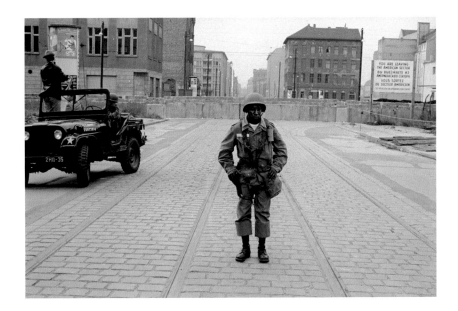

Freed's approach was both site-specific and historically conscious. His parents were Jewish immigrants, both from Minsk, Russia, who had escaped a wave of pogroms in their native land around the time of the First World War. In 1952 Freed sailed to Europe and eventually settled in Amsterdam, where he honed his craft as a documentary photographer.

Magnum, the renowned international photography collective, influenced Freed's method. Although often licensing prints for news publications, Magnum photographers were encouraged to be socially engaged and self-directed, to tell stories in long photo-essays and books, and to register visual relationships between themselves and their subjects through their work. In August 1961 Freed traveled to Berlin to witness the construction of a then weeks-old Berlin Wall. Among his first photographs of the wall is a single shot of a black soldier standing at the edge of the American sector of West Berlin (fig. 4). The image is emblematic of a central contradiction of postwar American culture: the soldier guarded America's Cold War frontline abroad but was denied full citizenship rights at home. This haunting image inspired Freed to pursue a project about segregation, eventually resulting in a photography book titled *Black in White America.*[2] Throughout this project, Freed attempted to capture his subjects' fields of vision—the looks shared among the people he photographed, and at times with the photographer—as a way of demonstrating the story of America's tacit but clear racial boundaries.

While attending the March on Washington, Freed sought images in which he could bring the marchers and the layers of their social landscape into a shared frame. The day offered Freed a spectacle—not for

marveling from afar or at a fixed distance, but for exploring at a ground level. Freed meandered through the assembled multitudes on the Mall. The resulting images attest to his thoughtful photographic eye, as well as active footwork throughout the day. As the crowd surged, Freed paced its myriad movements. He faced the Lincoln Memorial, the Reflecting Pool, and the Washington Monument as formidable visual anchors. He also traversed the spaces around and between these structures, playing with his angles to accentuate private moments and public displays.

In his photographs Freed portrays a woven collective of marchers: constituent groups holding banners representing their cities and states, union and clergy groups in uniformed regalia, a sweeping multiracial and multigenerational ensemble of participants dressed in their Sunday best (women in pearls, men with ties) on a sweltering weekday in August. The enormity of the event is best viewed through the sartorial details—the interplay of text and image on placards, the range of individual expression in close-up portraits. Freed sometimes snapped multiple frames of the same scene, moments in which marchers were in the midst of singing or chanting, attempting a cinematic-style capture. In each case, blurred faces or limbs that protrude into the frame further celebrate the dynamism of the event. One gets the sense that Freed was involved and also in the way.

By using a roving perspective and expansive frame, Freed's images of the march carry at least one historical peculiarity: Of the nearly five hundred images Freed captured that day, only one includes a glimpse of the day's keynote speaker, Dr. Martin Luther King Jr. (see page 63). The leader can barely be seen in a distanced, atmospheric shot taken at what appears to be the moment of his landmark "I Have a Dream" speech. As King speaks, Freed pivots, capturing both front and back shots of marchers looking up toward the Lincoln Memorial. With thousands of marchers separating Freed from King, this image serves as a collective and complex portrait of this historic moment from the participants' points of view.

Freed stayed on the Mall after the events of the day had passed, continuing to photograph into the evening hours. He reconnected with his wife, Brigitte, and they witnessed the last rendition of "We Shall Overcome" in which the remaining marchers linked arms and swayed. He continued to work as the crowd scattered away amid mounds of debris.

The following morning, the Freeds drove back to Brooklyn. By January 1964 they had returned to Amsterdam. Later that year Leonard made another trip to the United States on his own to travel through the South. He began this journey in Baltimore on October 31, where he photographed Dr. King at close range during a parade honoring the announcement of his winning the Nobel Peace Prize (see page 7, fig. 3). Freed then went back to D.C. to document black residents voting for the first time. In *Black in White America* Freed incorporates only four images from the march (two of which are shown here on pages 15 and 75),[3] as part of a larger story of racial struggle and reconciliation. Near the end of that book, however, he includes a long passage from the speech King delivered that day, opening with the words, "Even though we face the diffi-

culties of today and tomorrow, I still have a dream."[4] The use of this quotation was planned before King's assassination, but when it appeared in the book's first editions, the passage read as both urgent and elegiac.

Freed moved back to the United States in 1970 and became a full-time member of Magnum in 1972. In August 1983 he returned to Washington, D.C., to photograph the commemorative twentieth-anniversary March on Washington. He again approached the gathering from an active and historical perspective. His photographs speak to Martin Luther King's spiritual presence, with messages about the state of his "dream" encoded on signage that also depicts mournful images of the slain leader. The 1983 marchers sought to gain federal recognition of King's birthday, and images of the group evince the cultural shifts of the previous two decades, particularly the emergence of identity-based social movements, such as those advocating full rights for women and the disabled, inspired by King's legacy. And yet the photographs also attest to the reality that King's dream had not been fully actualized. Freed documents the continued call for full equality in the face of persisting forms of segregation. At the same time, he shows potent images of citizens gathered together, standing as one in democratic communion.

Freed returned to the Mall at least twice again to photograph new marches: the National March on Washington for Gay and Lesbian Rights in 1993 and the Million Man March in 1995. Altogether Freed offers persuasive visual testament to a then-emergent but now-ongoing fact of American history: no large public assembly on the National Mall can exist without recalling the momentous imprint of the 1963 March on Washington for Jobs and Freedom. Freed photographed and followed in the footsteps of those who marched that day, the men and women who walked the crossroads of the nation's capital to advance a dream of freedom and to glimpse the dawn of a new day for America. ∎

NOTES

1 Leonard Freed Papers, Garrison, New York.

2 Leonard Freed, *Black in White America* (New York, [1967/68]; repr. Los Angeles: J. Paul Getty Museum, 2010).

3 Freed, *Black in White America*, pp. 22, 132, 140–41, 145.

4 Martin Luther King, Jr., quoted in Freed, *Black in White America*, p. 202.

Biographical Notes

Julian Bond is a social activist and civil rights leader as well as a writer, teacher, and lecturer. While a student at Morehouse College in Atlanta, Georgia, during the early 1960s, he helped found the Student Nonviolent Coordinating Committee (SNCC). He was the first president of the Southern Poverty Law Center and was elected to both houses of the Georgia legislature, where he served a total of twenty years. He was chairman of the National Association for the Advancement of Colored People (NAACP) from 1998 to 2010 and is professor emeritus in the Department of History at the University of Virginia, Charlottesville.

Michael Eric Dyson is a widely published writer, media commentator, and professor of sociology at Georgetown University in Washington, D.C. He is the author of sixteen books, including *April 4, 1968: Martin Luther King, Jr.'s Death and How It Changed America* and *I May Not Get There With You: The True Martin Luther King, Jr.*

Paul M. Farber is a scholar, currently completing his doctorate in American culture at the University of Michigan, Ann Arbor.

Leonard Freed (American, 1929–2006) was a pioneer in the genre of socially conscious photojournalism. Born in Brooklyn of European Jewish parents, he began making photographs in 1954 and joined Magnum Photos as a full-time member in 1972. He photographed extensively in Germany, Holland, Italy, and Israel, and published numerous books and photo-essays. It was, however, his coverage of the American civil rights movement in the 1960s that brought him the most acclaim. His book *Black in White America*, first published in 1967/68, was reissued by Getty Publications in 2010. Freed's photographs are included in the collections of the Museum of Modern Art in New York, the Metropolitan Museum of Art in New York, and the J. Paul Getty Museum in Los Angeles.

© 2013 J. Paul Getty Trust

Published by the J. Paul Getty Museum, Los Angeles
Getty Publications
1200 Getty Center Drive, Suite 500
Los Angeles, California 90049-1682
www.getty.edu/publications

Dinah Berland, *Editor*
Jeffrey Cohen, *Designer*
Amita Molloy, *Production Coordinator*

Printed in China

Library of Congress Cataloging-in-Publication Data
Freed, Leonard.
 This is the day : the March on Washington / Leonard Freed ;
 foreword by Julian Bond ; essay by Michael Eric Dyson ; afterword
by Paul M. Farber.
 p. cm.
 ISBN 978-1-60606-121-3 (hardcover)
1. Civil rights demonstrations—Washington (D.C.)—Pictorial works.
2. March on Washington for Jobs and Freedom, Washington, D.C.,
1963—Pictorial works. 3. African Americans—Civil rights—Pictorial
works. 4. United States—Social conditions—1960–1980—Pictorial
works. 5. United States—Social conditions—1980- —Pictorial works.
6. Washington (D.C.)—Social conditions—Pictorial works. I. Dyson,
Michael Eric. II. Title.
 F200.F74 2013
 323.1196'07309046—dc23

 2012017313

Front jacket: Leonard Freed, Untitled, from March on Washington series,
1963 (detail, p. 55).
Back jacket: Leonard Freed, Untitled, from March on Washington series,
1963 (pp. 42–43).
Page i: Leonard Freed, Untitled, from March on Washington series,
1963 (detail, pp. 38–39).
Contents: Leonard Freed, Untitled, from March on Washington series,
1963 (detail, pp. 72–73).
Page 110: Leonard Freed, Untitled, from March on Washington series,
1963 (p. 71).

Notes to the Foreword

Bayard Rustin quotations are from the prospectus for the March on
Washington, prepared for A. Philip Randolph in December 1962 and
quoted in John D'Emilio, *Lost Prophet: The Life and Times of Bayard
Rustin* (New York, 2003), pp. 327–28.

John Lewis quotations are from Lewis's original March on Washington
speech, quoted in Fred Powledge, *Free at Last?* (New York, 1991),
p. 540.

Nick Bryant quotations are from Nick Bryant, *The Bystander: John F.
Kennedy and the Struggle for Black Equality* (New York, 2006), pp. 5–8.
All Nick Bryant quotations herein are copyright © 2007 Nick Bryant.
Reprinted by permission of Basic Books, a member of the Perseus
Books Group.

Illustration Credits

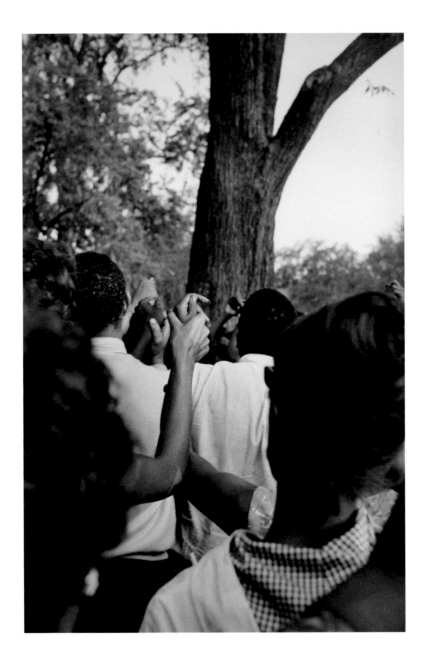